Creative
Watercolor

New Ways to Express Yourself

M ARCIA M OSES

Sterling Publishing Co., Inc.
New York

Edited by Jeanette Green
Designed by Lucy Wilner

Photographs of paintings by Dick Rogers Photography
Transparencies of paintings by Harold Thomas of J & R Photographers
Supplies photos by Stephen Ogilvy

Library of Congress Cataloging-in-Publication Data

Moses, Marcia.
 Creative watercolor : new ways to express yourself / Marcia Moses.
 p. cm.
 Includes index.
 ISBN 1-4027-1404-1
 1. Watercolor painting—Technique. I. Title.

ND2420.M647 2005
751.42'2—dc22

2004020418

10 9 8 7 6 5 4 3 2 1

Published in paperback in 2006 by Sterling Publishing Co., Inc.
387 Park Avenue South, New York, NY 10016
© 2005 by Marcia Swartz Moses
Distributed in Canada by Sterling Publishing
c/o Canadian Manda Group, 165 Dufferin Street,
Toronto, Ontario, Canada M6K 3H6
Distributed in the United Kingdom by GMC Distribution Services,
Castle Place, 166 High Street, Lewes, East Sussex, England BN7 1XU
Distributed in Australia by Capricorn Link (Australia) Pty. Ltd.
P.O. Box 704, Windsor, NSW 2756, Australia

Sterling ISBN-13: 978-1-4027-1404-7 Hardcover
 ISBN-10: 1-4027-1404-1
 ISBN-13: 978-1-4027-4047-3 Paperback
 ISBN-10: 1-4027-4047-6

For information about custom editions, special sales, premium
and corporate purchases, please contact Sterling Special Sales
Department at 800-805-5489 or specialsales@sterlingpub.com.

To the Poet, Diana Loomans

The Art of Being

The greatest artists one can ever know
are the artists of being,
who, without paintbrush,
chisel, or stroke of pen,
bring more aliveness to the world around them.

Their very presence generates beauty,
for their lives are their works of art.
They are masters of the moment,
moving through each hour with graceful ease, and painting
the canvas of their days with the vivid hues of love.

Their passion for life is their medium,
bringing fresh bursts of inspiration
wherever they are,
and leaving strokes of uncommon wisdom
wherever they go.

They embrace all of life—
their arms outstretched in a wide arc of splendor.
For all that has been, they are grateful.
For all that is to come, they are welcoming.

Their response to life is a resounding yes.
Their hearts are as open as the sky.

—Diana Loomans © 2004

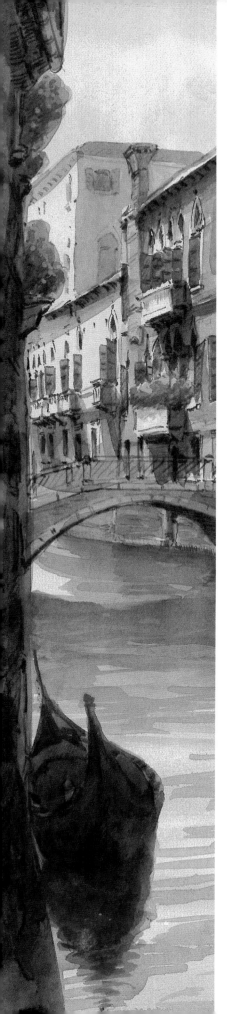

CONTENTS

Heart, art, and spirit! That's Marcia!

Marcia first introduced herself to me about fifteen years ago. Her green eyes and spirit captivated me, and we were immediately friends…for life!

Over the years, I attended many of her workshops and seminars. As a professional painter, I feel there is always more to learn, and Marcia's bright spirit always energizes my art.

All that she accomplishes in her books, artwork, teaching, and life is a tribute to art. Her works and words continue to inspire everyone who knows her.

There's much to learn from her dedication to her craft and her dynamic, heartfelt knowledge of the watercolor art. Enjoy her words; they are filled with brilliant inspiration that's the very essence of the visual arts.

Enjoy, benefit, and profit from this wonderful teacher. May we all grow through *Creative Watercolor.*

—James F. Penland, Founder and President
Ocean City Fine Arts League
Ocean City, New Jersey

Sand Dollars
Marcia Moses, 8½ × 16 inches

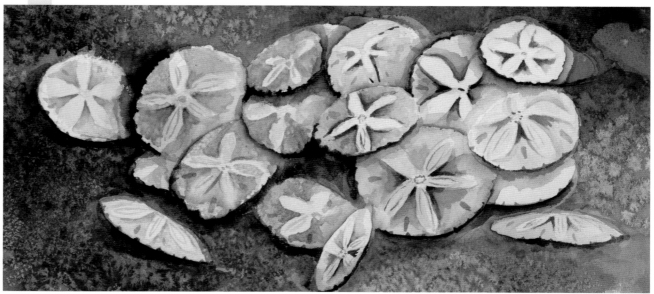

Introduction

When I think of painting in watercolors, I imagine opening a sand dollar. Separate the shell and you'll find a delightful surprise—five little doves. Well, if you open your mind and use your imagination while painting, you will also encounter many wonderful surprises.

My goal with this book is to guide you along a path in painting that will enable you to encounter those surprises. I also want to teach you how to use them to create beautiful art that conveys the images in your mind as well as the emotions in your heart.

Certainly, practiced technique and proper equipment are vital to your accomplishment as an artist. But just as important as these is your willingness to let yourself leave your comfort zone, to ignore your fears, and to allow your creativity to have its way with your art.

Artists, even experienced ones, at times struggle with unleashing their creativity. Novice artists frequently explain, "I know what I want it to look like, but I can't put that on the paper." The barrier is more than a lack of technical skills. An instructor may have taught the students those skills only moments before. But the fear of putting the techniques to work can overwhelm an image held in the mind.

Desire and passion are the keys to unlocking your creativity. If you want to paint, you can. If you need to paint, you will. And once you begin putting the paint to paper with your heart and soul, instead of just with your mind, your art will be guided by your creativity. What you feel will help you paint what you see.

Become open to change; change breeds success. Each artistic technique you learn can lead to another one you discover.

Sometimes it is hard to leave that comfort zone where you face few risks. Learn to take risks and you will be surprised at what that does for your self-esteem. Become a positive thinker. The Beatles were turned down by thirty-four record companies before landing a contract. They didn't give up on their dream. The desire was there, and they persevered. Successful people will almost always tell you that it was rough in the beginning. They also will say that it was worth the struggle.

Open that sand dollar and be pleasantly surprised by the artist you find within yourself.

— *Marcia Moses*

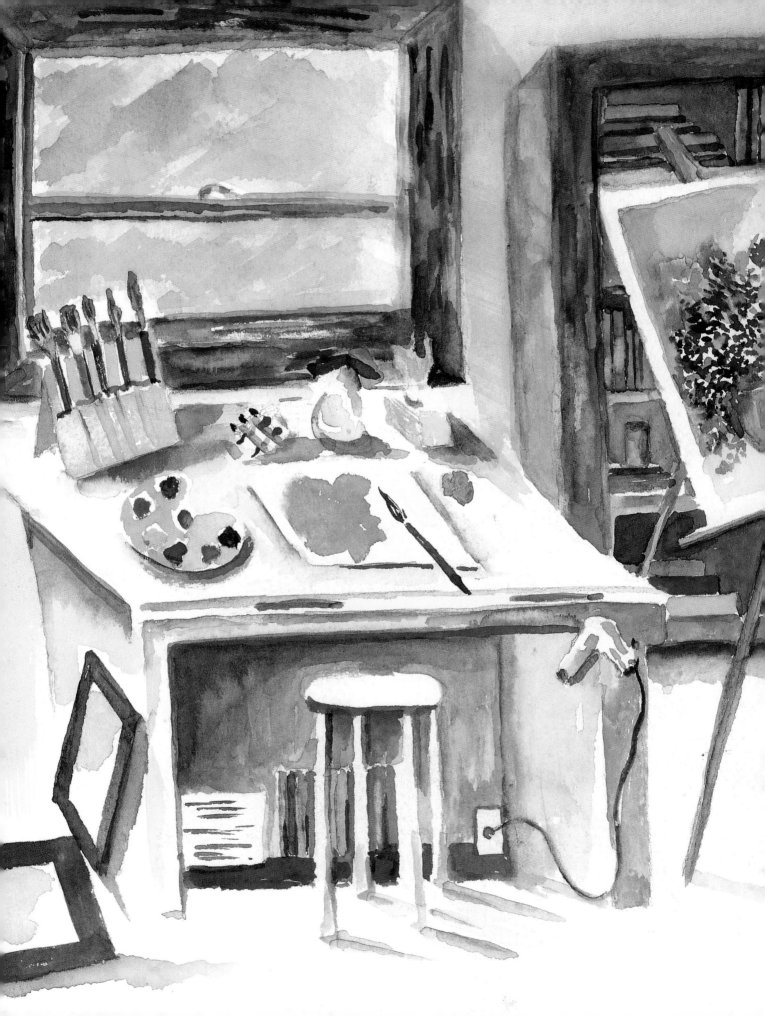

Inside the Artist's Studio

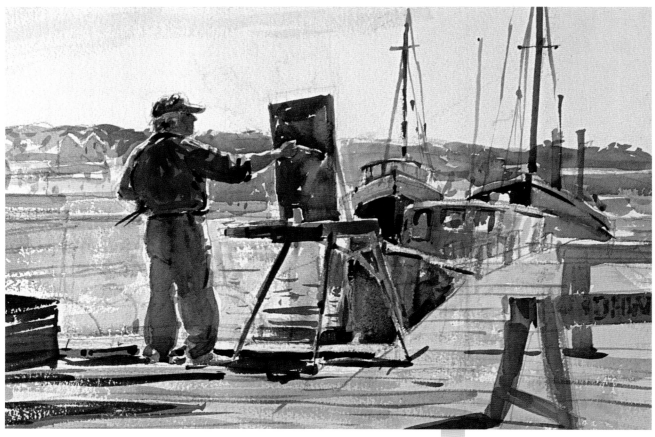

Detail of **Painting at the Wharf**
Jeff Weaver, 11 × 14 inches

AN ARTIST'S TOOLS

*"See it in terms of paint.
We don't learn subject
matter, we learn paint.
A musician can play any
score that is set before
him."*

— HELEN VAN WYK

ARTISTS ARE NO DIFFERENT than other people who have special talents and interests. We are always looking for new art supplies. Just going into the art store or looking at a catalog can get the creative juices flowing.

Unfortunately, we can find ourselves spending money on supplies we'll never use. Still, I don't consider the time spent looking for materials as wasted, because I am excited when I find a new product that actually fits my needs and will help improve my work or make painting more fun. It is important to be selective when we shop, however. Become a painter, not a painting-supply collector.

Here are some tools that work well for me. Of course, you'll need to experiment to see which ones suit your style and needs.

PAINT

There are many paints on the market, and I've tried most of them. Quality is always better than quantity. Holbein tube paint has the quality I expect for my paintings. However, there are a few other brands I choose to use more selectively, including colors from Cheap Joe's American Journey, MaimeriBlu, and Winsor & Newton. For pan paints, I like Yarka St. Petersburg Artists' Water Colours.

Tube paint is best.

BRUSHES

Again, for most painters, less is more. Most brushes I use are inexpensive and of high quality. I use Holbein's 1½-inch flat, 1-inch flat, ¼-inch flat, #4 round, and #6 round brushes, and I occasionally use a grass comb brush made by Silver Brush.

I also choose several other brushes for definite reasons. Stratford & York brushes, for instance, have good holding power, and the brush bristles flow easily over the paper. They also have good snap-back power.

Black Gold brushes, made by F&W, are terrific. I especially like the rounds and use a #24 and a #18 to do fine detail work or to create lovely strokes for leaves. These rather large brushes have a fine tip. They're also great for highlighting and shadowing, as well as for washes. These multitask brushes have great paint-holding power in the belly of the brush. They can do the work of both a #4 round and a wash brush.

Choose your brushes carefully

MASKING FLUID

I have recently discovered a masking fluid that really makes masking (preserving whites) easy. Cheap Joe's has a masking fluid that includes the brush in the bottle. This eliminates the need to rub the bristles in Ivory soap between each application to save your brushes, as is necessary with the traditional masking fluid I've used for years. In the past, I would avoid using masking fluid at all because of all the work involved. Now I encourage its use because I love the convenience of this new product.

Perhaps even more convenient for detailed masking is the squeeze-bottle applicator of artist's masking fluid offered by Masquepen. The brand name is appropriate, because the bottle can be used as a pen, with small amounts of masking fluid applied to paper through a tube at the top of the bottle.

Masking fluid comes in handy.

Robert E. Woods palette.

Choose the watercolor paper that's right for you.

An easel for propping up your painting.

PALETTE

I really love the Robert E. Woods palette. It is convenient to carry, and its deep wells make it easy to transport and store paint. Cheap Joe's Art Stuff also has a wonderful palette called the Piggyback palette. This palette has a snap-on extra palette that allows you to carry additional paint to a location. I love it.

WATERCOLOR PAPER

Many different kinds of watercolor papers are available on the market. Some are more forgiving than others. You may choose from 140# to 300# cold-press, hot-press, or rough varieties from various manufacturers, like Fabriano, Arches, and Strathmore. All are acceptable. I prefer to use 140# cold-press paper.

EASEL

Shop around for an easel that feels most comfortable for you. Check the height and added features. Some are lighter and therefore more portable than others. Some small table models may work for you if you have limited space.

OTHER SUPPLIES

A few other helpful supplies to keep in your studio include a sketchbook or sketch pad, pencils, a toothbrush, an atomizer, gummed erasers, masking tape, a T-square or ruler, sponges, and sea salt.

Plein-Air Materials

While it's hard to replace the solitude a studio affords an artist for putting finishing touches on paintings, there is a whole world outside, waiting to be captured on watercolor paper. The best way to become acquainted with city and country artistic possibilities is to pick up your brushes and your paints and try plein air—painting outdoors. (The literal translation of *plein air* from the French is "open air.") I guarantee that you'll fall in love with it.

There's nothing quite like standing in natural light, breathing fresh air, and painting landscapes, flowers, or buildings that are real, instead of using photographs. Nevertheless, keep a camera handy to capture the light when you deem it perfect, so that you can duplicate the particular setting when you complete your artwork back in your studio.

What to Tote When Painting in Plein Air Here are a few things you may need for plein-air painting. Of course, you'll want your palette, brushes, and paints. Cheap Joe's has a small palette that's very convenient to tote and has a large enough mixing space for plein-air painting. Also check your favorite art store.

Paper towels for cleaning your palette and brushes and tissue for dabbing and collecting paint.

A hat to keep the sun out of your eyes.

A sketchbook or pad for making preliminary sketches.

An umbrella for sunny days or inclement weather.

Make a handy pack to take with you when painting outdoors: a toothbrush, atomizer, gummed eraser, and masking fluid.

The Brush and Its Properties

Knowing how a brush is put together and how it will work on the paper you choose are essential to your painting.

On the market are numerous brands of brushes that all promise to do the job they were intended for. When purchasing specific kinds of brushes, the artist can be misled by sometimes inflated proclamations by the manufacturer. Word of mouth from other artists is a great way to get to know the pluses and minuses of different brushes, but there also are ways to test a brush you want to buy with or without actually putting the brush into paint and water.

The idea that the more you pay for a brush the better it will work for you is a myth. As do many artists, I fell for that myth in the beginning: I thought that if I paid a lot for my brushes, I would be a better painter.

The truth is that I use three brushes almost exclusively and rarely more than six. While they all are inexpensive, they have the quality and performance I expect in a brush. The most important qualities a brush must have to make it a good tool can be determined from a visual inspection and a "test drive" in the store or in your own studio.

Since in later chapters I will be referring to all parts of the brush, it is important to know these by name for your own reference.

Note the anatomy of the brush (on p. 15); the tuft of brush hairs is attached to the ferrule, and the ferrule is attached to the handle. How these three parts of the brush come together is what gives it good quality. The tuft is sometimes already attached to the ferrule when the handle is attached during final assembly. In other cases, the tuft is made separately. The hairs are cupped (set into a form) to the appropriate size and thickness, and then they are tied tightly at the base. An adhesive is applied to secure the hairs in place.

The ferrule shown here is made from a corrosion-resistant metal, such as copper, nickel, or aluminum. In the best brushes, the ferrule is either double- or triple-crimped, and sometimes quadruple-crimped, at the handle. Other brushes may have a crimp just below the tuft to ensure the hairs' stability.

The handle is made from a dense hardwood to achieve straightness. The wood is sealed with a chemical and then dipped into a lacquer or polyurethane. Sometimes acrylic handles are used for synthetic brushes.

When I begin painting, I am in a state of unconsciousness; I suddenly forget that I am holding a brush in my hand." —WU CHEN

How to Test a Brush

In most cases, you can't walk into an art store and expect to wet the tuft and see how it holds up with water and paint on it. I have been fortunate enough to go to many manufacturers' conventions where you can handle various kinds of brushes and put them to the test. You may be able to do the same thing at trade fairs, or you can buy a representative brush and put it through its paces in your studio. The chances are good that if you like that brush, you'll like many others that the company manufactures.

Wet the tuft thoroughly. This will load the hairs with water and expand the tuft. Hold the brush from the bottom of its handle and flick it forward with your arm, using your elbow. The hairs of a good brush bounce back into shape when flicked. Flat brushes should come back with a beveled edge, rounds should come to a point, and there should not be split or straggling hairs.

Some brushes hold more water than others. Good brushes hold more water, and thus more paint, which is critical for applying washes.

10 Tips for Choosing a Brush

What makes a good brush? Although there are no universal rules, most watercolorists look for these ten attributes in a brush.

1. Clean shaping. When water in a brush is released with a flick of the arm (from the elbow, not the wrist), its bristles should immediately return to a clean profile. Flats should come to a bevel edge and rounds to a needle point, without stray or splaying hairs.

2. Crisp edging. When moderately charged with paint, a round brush should be able to render a crisp, thin line and a variety of very small stippling or hatching marks. A flat should be able to "chisel" repeatedly, making even line segments by holding the brush vertically and tapping the paper lightly with its edge. These marks should be easy to control and should vary depending upon whether the brush is heavily or lightly charged with paint.

3. Spring or snap. The bristles should flex to track changes in the direction and pressure of a brushstroke. As the brush is pressed into the paper, the bristles should bend together. Then, as the direction of the stroke changes, the bristles should flare, traveling in unison across the paper. And as the brush is lifted from the paper, the bristles should come away in perfect shape, ready for the next stroke. Each shift in direction is called a gesture, and a good brush should be able to create a wide range of these gestures.

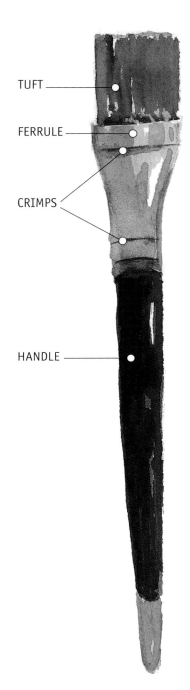

TUFT

FERRULE

CRIMPS

HANDLE

The anatomy of a paintbrush.

4. Large capacity. For its type and size, a brush should hold a generous amount of paint or water. This varies with the type of bristles and the way they have been cupped, but comparisons with other brushes of similar size will reveal significant differences in carrying capacity.

5. Even release. A brush should release paint in an even flow. The color of the stroke should be even across its entire length and width. The brush mark should not start with a puddle of paint that leaves a dark blossom when it dries, and the brush should lift from the paper without wicking off a puddle of paint at the end of the stroke. When the brush is heavily loaded with paint, it should show much the same release characteristics as when it is carrying little paint. Between cleanings, rinsewater should release when the brush is shaken or wiped, so that a new load of paint is not diluted by water held in the brush.

6. Ease of cleaning. Pigment should not only rinse easily from the bristles during use, it should wash out at the end of a painting session with only small applications of soap. Bristles should withstand discoloration from staining pigments. Sedimentary pigments should not build up in parts of bristles closest to the ferrule.

7. Durability. A brush should withstand frequent and long use. Bristles should retain their characteristic spring, shaping, and release, and they should not splay, break, or fall out.

Assemble your favorite tube paints.

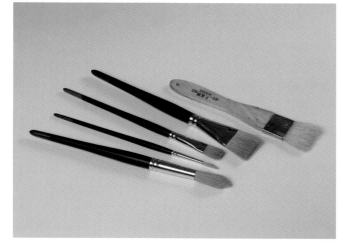

Use a variety of brushes. These are Holbein Black & Gold and a hake brush that's made in China.

8. Resistance to moisture. The brush handle should not warp, swell, or crack after long exposure to water. The ferrule should remain tightly secured to the handle. The finish of that handle should not crack or chip.

9. Balance. The brush should rest comfortably in the hand. The weight or center of balance of a moistened brush should be at the widest swelling of the handle, just behind the ferrule. The length and shape of the handle should not force you to hold the brush in an awkward position.

10. Elegance. After much use and effective contribution to an artist's work, a brush can develop a personality. An artist can become so fond of a particular brush that its use by another artist can be irritating. A brush's natural elegance—its look and feel—plays a significant role in the relationship between an artist and his favorite brushes.

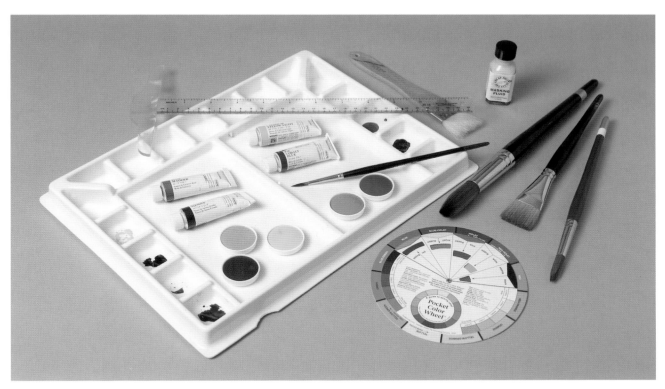

Stock your artist's studio with a palette, tube paints for every day, pan paints for travel or outdoors, a T-square for perfect measurements, masking fluid, a color wheel, and an assortment of brushes.

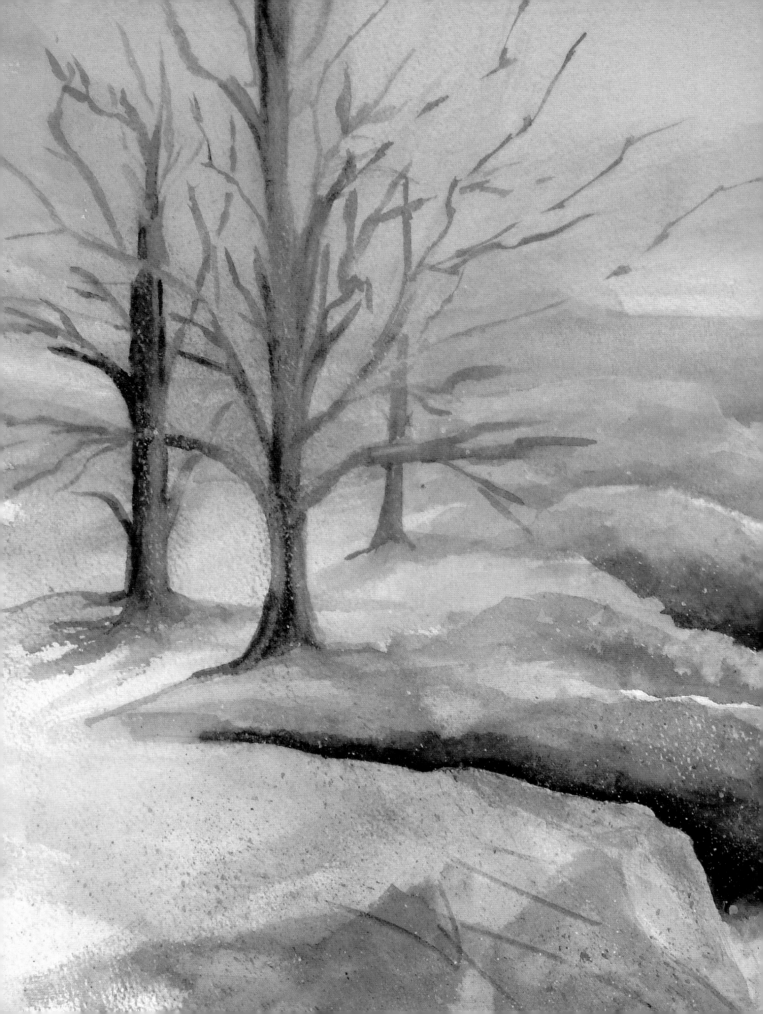

Composition & Design

"Composition is the art of arranging in a decorative manner the various elements which the painter uses to express his sentiments. In a picture, every separate part will be visible and...everything which has no utility in the picture is for that reason harmful."
—Henri Matisse

Apples
Marcia Moses, 12 × 30 inches

COMPOSING YOUR PAINTING

THE PLACEMENT OF IMAGES in a painting is crucial to the artwork's visual impact. The simplicity of the images often is their strength, but they cannot be randomly placed.

Instead, intelligent artists plan in advance how to position the colors and objects in their paintings. Planning a composition in advance is perhaps even more important in watercolor than it is in oils or acrylics. Unlike many other media, the darks of watercolor cannot be painted over with lights, unless those light colors are opaque. It can be very difficult to remove staining colors after they are put on the paper.

For these reasons, an artist needs to visualize where the lights and whites of a painting will be. It can be difficult to achieve large areas of white space with white watercolor paint, and purists disdain even minor use of the pigment. They prefer to preserve whites and to plan ahead for light areas and open space. Whites, light areas, and open space are often just as important to a painting's composition as the colors in it.

Composition means selecting appropriate elements and arranging them within the picture space to communicate the artist's ideas and

feelings to the viewer. The painting's composition can create a strong, interesting work; a weak, confused one; or something in between. In your composition, you want to combine forms and space to produce a harmonious whole that also makes a meaningful statement.

Really great works of art don't just happen. They're not the result of simply throwing together objects or filling in background with unplanned details. They are the result of careful planning without which viewers could be left feeling confused and unsatisfied. A well-composed painting will draw viewers into it, hold their interest, and leave them satisfied.

Each artist approaches a given subject differently. One may favor a romantic approach to the subject, while another may want to portray it realistically. Still another may prefer working with different textures that depict the subject abstractly. The painting's composition helps the painter say what he wants to say.

In composing your painting, you decide what your main point of interest will be. Although another artist may see the same subject or scene, he may choose a different point of interest. The forms used to create this point of interest may be made larger, clearer, stronger, and brighter than they actually appear in real life. Less important forms may be created smaller or less distinct. Perspective is very important.

Through composition and having a main focal point, the artist can actually control which part of the painting viewers will linger over. After a definite focal point has been established, the viewer can be led either directly or indirectly through the work. The use of light and dark contrasts will also help emphasize the center of interest.

The artist needs to have an idea about the subject and then determine what he needs to do to compose the subject within the painting in the most effective way. The artist must ask himself: What kind of mood do I want to create? What emotions do I want to evoke? What content in the painting will captivate viewers and allow them to grasp what I've envisioned? Will anything in the painting distract viewers, and should I move or remove it? Is this the very best composition for this subject? Are the proportions correct?

After the artist answers these questions and more, it's time to begin to put the ideas on paper. Rough sketches help ensure that the composition is correct and that the picture will capture the feelings the artist wants to convey. Sketches should be kept simple and broad and not contain a lot of detail. If the artist believes that these sketches capture the effect, focal point, rhythm, design, and feeling he wants to create for viewers, the sketches can be transferred to the final work of art.

The Elements of Design

Let's review the elements of design.

Shape A spatial form, contour, or figure, such as a geometric shape, circle, square, triangle, or a combination of these in a two-dimensional pattern.

Space The relationship of the area occupied by one shape to that occupied by another shape. Space is important when we are using perspective to tell the viewer what is in the foreground, middle ground, and background. As objects move back, they appear to become smaller.

Line There are two ways to describe line. One is the marks made with a pen, pencil, or brush. But in design, line usually refers to achieving a pleasing arrangement of curved or straight lines by making one or the other dominate.

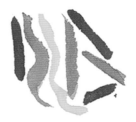

Texture The surface condition of a shape—rough or smooth, hard or soft. In a painting, texture can be "felt" with your eyes and sometimes with your hand.

Value The value of a hue is determined by its intensity. There is a value range from 0 to 10 with 10 being void of color and 0 being the full color range. Some value scales may reverse that, and give 10 as full color and 0 as void of color.

Color Watercolors are pigments ground in water and bound with gum arabic. The pigment provides the color: red, yellow, blue, orange, green, violet, etc. In watercolor, the ultimate goal is normally to have transparent colors so that beauty and light shine through the pigment.

Form Form is the surface characteristic of an object. It describes an object's three-dimensional qualities, such as its roundness or volume. The shape of an object suggests the form, but the object's true nature is revealed through variations of light and shadow.

The Principles of Design

Unity The placement of design elements in relation to one another creates unity in a painting. All design elements play off each other and influence the whole.

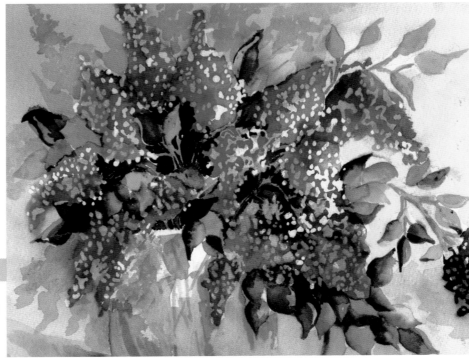

Abigail's Wedding
Marcia Moses, 11 × 14 inches

Harmony Harmony in a painting is the visually satisfying effect of combining similar, related elements, such as shapes, or colors that are adjacent on the color wheel.

Balance You don't want a painting to look lopsided. Balance is the result of placing objects and colors throughout the work, using their relationship to each other to create unity in the composition.

Rhythm Variety and repetition of design elements create rhythm in a work of art.

Nancy's Rock Garden
Marcia Moses, 22 × 30 inches

Contrast The major contrast in a painting should be located at the center of interest. Provide contrast within each element, playing light against dark, soft against hard, or warm against cool.

In the painting *Iris,* note the contrast within the flower.

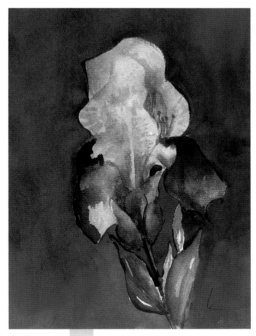

Iris
Marcia Moses, 5 × 7 inches

Dominance One part of a painting should dominate the others. That is the painting's center of interest, or focal point. It is like having the main role in a play, and all the other parts are the supporting cast.

In the painting *Surfside*, the dominant part of the painting is the white of the wave. The white wave against the dark blue of the ocean causes the eye to be immediately drawn back to that area. It conveys dominance over all other elements.

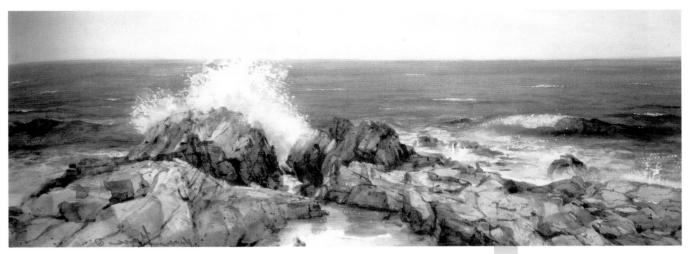

Surfside
Marcia Moses, 6 × 20 inches

Gradation This creates a three-dimensional effect. Gradation of a color from warm to cool and of a tone from dark to light can produce interest.

In later chapters, we'll be dealing with all these elements and principles, and we'll learn how to use them to our advantage.

Locating Hot Spots

Arranging all the elements on a blank piece of paper can be intimidating and frustrating. Nevertheless, in order to make a composition pleasing to the eye, these elements must be organized. Using a grid to arrange a composition makes the process much easier. The simple grid, with four hot spots identified by crossing lines, gives you a set of guidelines to arrange the elements on the paper with purpose. The grid allows you to lead the viewer's eye to the center of interest, or focal point, which should be placed at one of the hot spots.

To make a painting successful, the center of interest should be obvious and well-positioned. Avoid placing the center of interest in the middle of a painting (either horizontally or vertically) unless you are trying to create a static, formal composition.

An easy frame of reference for position of your center of interest is to keep it an unequal distance from each side. Use the grid shown here as a guideline.

Grid showing hot spots (dark circles) for where to place the focal point, or the painting's center of interest.

Easy Drawing Techniques

After being frustrated with my drawing technique early in my career, I decided to try to find a simpler way to produce the sketches that provide basic designs for my paintings. I began by breaking down each object in a sketch into basic shapes.

For example, a decanter like this one (shown at right) contains many shapes. Beginning at the top of the decanter, notice there is an ellipse. Just below the ellipse is a cylinder. Below the cylinder is another ellipse. Below the ellipse is a triangle shape, topped by an ellipse. Under the triangle shape is a cylinder, also topped by an ellipse. And at the bottom there is another ellipse.

When drawing an object, you need to get to know the object. Touch the surface and feel the texture. Look inside it, behind it, and through it. But it is important not to try to sketch the entire object. Imagine all the shapes that can be found in that object, and start putting them down on paper. Shape by shape, a sketch of the object will appear. Drawing is so much easier for me when I follow this simple exercise.

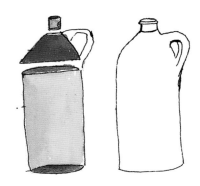

This decanter is made up of ellipses, cylinders, and a triangle.

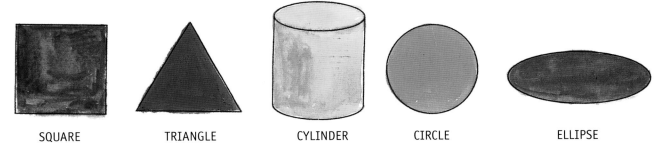

| SQUARE | TRIANGLE | CYLINDER | CIRCLE | ELLIPSE |

A few basic shapes like these help simplify the drawing process.

Creating several small thumbnail sketches of the same basic painting allows you to shuffle the subject around and adjust the composition before you begin to paint. Having a sketched plan makes it much easier to avoid design problems, particularly when it comes to arranging contrast between light and dark values of a painting. Break your thumbnail sketches into about four different tonal areas and shade them. This allows you to manipulate the lights and darks so that the maximum contrast occurs at the center of interest.

Contour Drawing

The drawing for a watercolor painting should not take anywhere near the time it would to paint the subject. I draw in an entirely different way when drawing for a watercolor painting than when drawing for its own sake.

"Drawing is the artist's most direct and spontaneous expression, a species of writing: it reveals, better than does painting, his true personality."

—EDGAR DEGAS

When drawing for watercolor, I usually do a contour drawing, in which all visual information is stripped to basic shapes. Instead of seeing identifiable objects, I look for the shapes created by light, color, and contour. Most often, these shapes do not have a name; they are simply shapes.

For example, when painting from the picture of the sailboat shown here, I did not sketch any of the details of the boat or landscape. I simply drew a basic outline of the shape of the boat hull and sails, and I added a couple lines to depict the water, trees, and sky in the background.

By not putting in a lot of information at the drawing stage, I am able to be looser in my handling of the paint. I remove any pencil lines that I do not need. I draw quite faintly so that I can remove drawing lines when I have finished painting.

For some reason, it seems to be more difficult to remove pencil from areas that contain yellow; so be especially careful about unwanted pencil lines in these areas.

Before applying any color, I use masking fluid to mask out areas which must remain white or light.

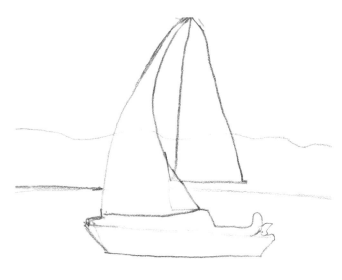

Sketch of a sailboat for a watercolor.

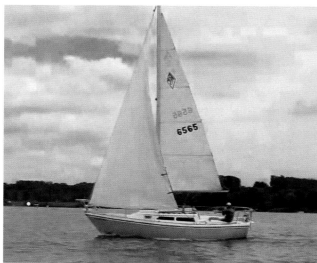

Photo of a sailboat (subject for a painting).

Drawing Tips

1. Practice.

2. No matter what you are drawing, it is important to first consider how your subject will be placed on the page. Making small thumbnail sketches before you begin your drawing is a good way to work out the composition.

3. Work from large and bold to fine and detailed. Start your drawing by mentally reducing the subject to a few simple shapes. Sketch these in lightly and accurately, and then proceed to break these up into smaller, more detailed shapes. Don't start at one corner of the sketch and work your way across to the other side of the paper, drawing in everything you plan to paint. Instead, sketch in the outlines of important shapes, and fill in some detail later.

4. Your drawing will look better if the most interesting part (called the focal point or center of interest) is not placed along either of the page's center lines. The strongest contrast in values should be placed at the center of interest, one of the hot spots.

5. Have some areas of the drawing less detailed than others. Try to keep most of the detail in the area of the center of interest.

6. Stand up, work on a vertical surface (or a surface at right angles to your line of vision) and move your arm from the shoulder. You only need to do the final finishing off with small, tight hand movements.

A T-square and masking tape can be useful tools.

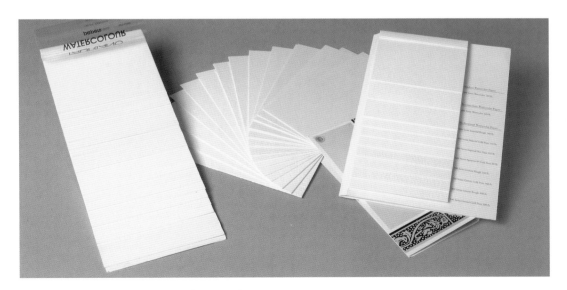

You can choose from a variety of watercolor papers.

7. Try standing and working on a flat horizontal surface. This will allow you the freedom to work with your entire arm rather than just your hand. Also this will give you an overhead view of the painting so that you can watch its progress from a greater distance. You can easily step back from your work from time to time. Distance sometimes gives you a different perspective on a painting.

8. Try using an easel. Controlling the paint may not be as easy in the beginning. The paint will tend to flow to the bottom of the paper, depending upon the amount of water you use. But this can be a good thing when it comes to blending colors. Using an easel also allows you to view your artwork in an upright position, as it would be seen in a gallery.

9. Occasionally sit down to paint, or take a break from painting and move around. Clear your mind and stretch your body, then return to your easel or drafting table with a fresh outlook on your artwork.

Pumpkin Patch
Marcia Moses, 6 ½ × 16 inches

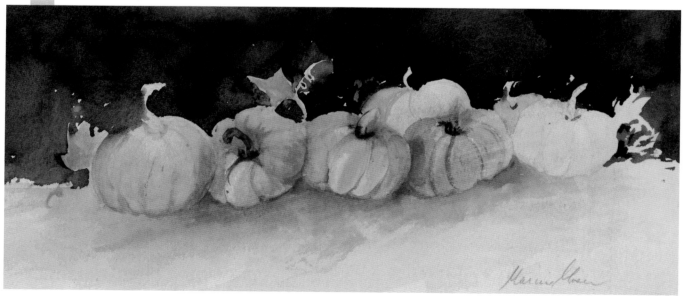

The Secrets of Perspective

Sometimes it's very easy when designing a painting to avoid considering its perspective, and I completely understand that feeling. Perspective can be complicated. Putting a painting into perspective can be a bit taxing to the creative soul. However, we all know how very essential perspective is to the drawing and painting process. When an artist avoids sketching and painting in perspective, it usually is a huge, and eventually a very frustrating, mistake.

Painting in perspective, however, need not give you a headache. In the next few pages, we'll simplify the process. We'll discuss ways to make learning and applying the principles of perspective not only easy, but fun. Learning a few commonsense rules for the way objects relate to one another and to the space they occupy will enable you to draw and paint those things you have been avoiding, and your art will improve immensely.

Perspective, in theory, is re-creating objects on paper in the manner that they would exist in real life. We see a railroad track as moving away from us, getting narrower and smaller, until our eyes no longer can see it. If we paint those tracks without perspective, for example, as two parallel lines, they will not fade away into the distance and will lack depth. Regardless of the quality of any drawing or painting, if the perspective is off, the artwork will not be believable. We'll talk about two types of perspective: one-point and two-point.

"Perspective is to painting what the bridle is to the horse, the rudder to a ship."

— LEONARDO DA VINCI

One-Point Perspective

The best way to describe one-point, or linear, perspective would be first to find your vanishing point. This is located on the horizon line. The horizon line is always at eye level. Picture yourself in a field of grass where the sky meets the field at your eye level. Think of sitting down in a field and looking up at the sky where it meets the field; this is also at your eye level.

Your horizon line always falls at eye level regardless of where you are looking. For instance, if you are looking down at something, your eye level remains at the level of your eyes, not down where you are looking.

Beach Walk
Marcia Moses, 11 × 14 inches

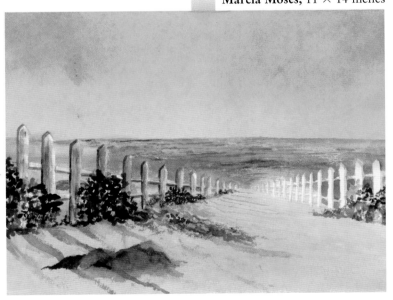

The painting Beach Walk *is in one-point perspective.*

DRAWING EXERCISES IN ONE-POINT PERSPECTIVE

Marking the Horizon Line and the Vanishing Point In Diagram A, I first drew a horizon line at eye level. Then I drew a second horizon line and added a vanishing point.

Step 1

HORIZON LINE

Step 2

VANISHING POINT HORIZON LINE

Diagram A

Drawing in One-Point Perspective Diagram B is an example of a drawing done in one-point perspective. I drew a number of squares at various levels above and below the horizon line (HL). From each corner of each box, I drew a line directly toward the vanishing point (VP). This exercise shows the different views of a shape seen at various angles.

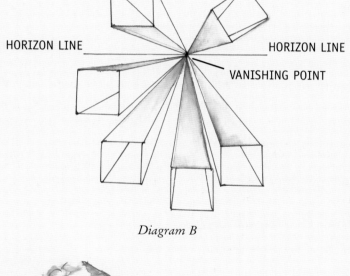

HORIZON LINE HORIZON LINE

VANISHING POINT

Diagram B

Drawing a Landscape Diagram C demonstrates how the rules of perspective apply to a landscape. The trees appear to get smaller as they recede down a road. The point where they disappear is called the vanishing point. This example illustrates one-point perspective. Note how high the horizon line is on the drawing. The lines coming together at the vanishing point are called converging lines. These lines allow the viewer to be led into the drawing or painting, thus creating the illusion of depth and distance.

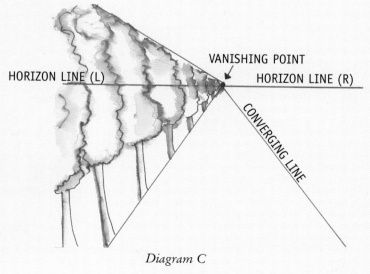

VANISHING POINT

HORIZON LINE (L) HORIZON LINE (R)

CONVERGING LINE

Diagram C

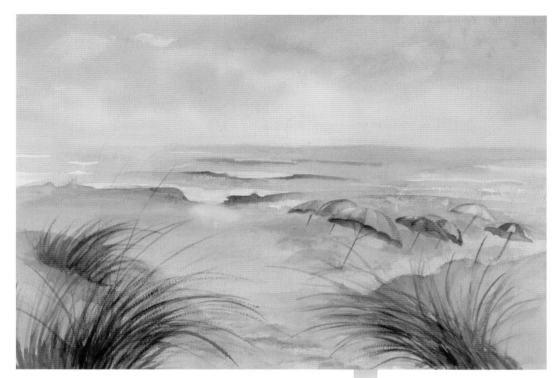

The painting Beach Umbrellas *shows one-point perspective. Note how the windblown beach umbrellas softly fade as they approach the ocean. The beach grass on the sand dunes closer to the viewer outsize the beach umbrellas. The distant waves indicate a blustery day. The ocean at the horizon line seems to fade into the sunset.*

Beach Umbrellas
Marcia Moses, 15 × 22 inches

Two-Point Perspective

In two-point perspective, there are two vanishing points, one to the left of the horizon line and one to the right. This is important because not all structures, such as buildings or houses, will be situated with their fronts parallel to your view or picture plane, as is the case with one-point perspective. Drawing in two-point perspective results in an object with a corner pointed toward the picture plane, instead of a side.

In diagram D (on p. 34), the horizon line is above the object, and the vanishing points are on both sides of the horizon line. The diagram identifies those vanishing points as vanishing point left (VPL) and vanishing point right (VPR).

To duplicate the object drawn in this diagram, move below the horizon line and draw a vertical line about 1 inch long anywhere you want on the paper. I chose to draw the line in the demo just off center. With your ruler, draw a line from the bottom of the vertical line to the VPL. Draw the next line from the bottom of the vertical line to the VPR. Those lines establish the bottom of the box.

Repeat the lines from the top of the vertical line to both vanishing points. This establishes the top of the box.

Two-Point Perspective

You are now ready to draw two vertical lines on either side of the middle line. This will establish the sides of the box. Draw a line from the top of the left vertical line to the VPR and a line from the top of the right vertical line to the VPL. This further distinguishes the top of what has become a three-dimensional box.

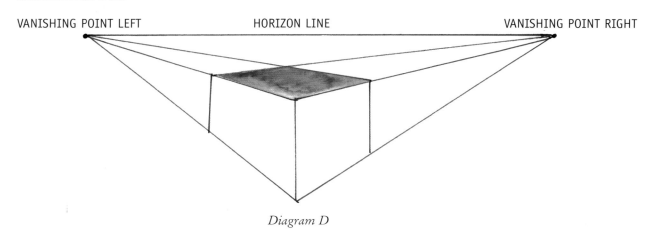

VANISHING POINT LEFT HORIZON LINE VANISHING POINT RIGHT

Diagram D

DRAWING EXERCISE IN TWO-POINT PERSPECTIVE WITH AN INCLINE VANISHING POINT

Step 1. Begin this exercise by drawing the horizon line. At each end of the line, place a dot and mark the points with vanishing point left (VPL) and vanishing point right (VPR). Next draw a vertical line in the center of this line and mark the top with an A and the bottom with a B. This line denotes the corner of your house. Draw a line from A to VPL, and a line from A to VPR. Also draw lines from B to VPR and to VPL. Below is how the beginning diagram should look.

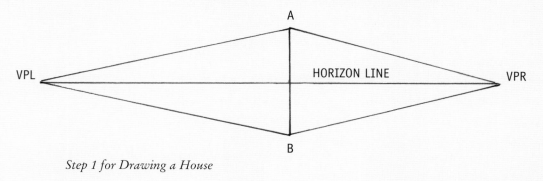

Step 1 for Drawing a House

Step 2. Add a vertical line through the horizon line to the left side of the diagram about halfway down the horizon line, and mark it C at the top and D at the bottom. This will be the left side of the building.

Draw another vertical line through the horizon line to the right of the A–B line, about a fourth of the way down the horizon line toward the vanishing point. Mark this E at the top and F at the bottom. You are now looking at a box from the corner view. Notice that the right end of the box is smaller than the left. This is where the peak of the roof will be placed.

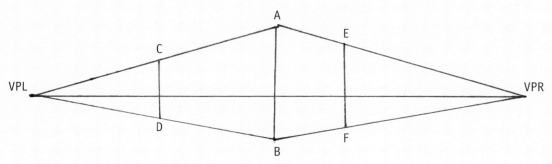

Step 2 for Drawing a House

Step 3. Now you are going to make an X on each side of the building to determine the center in perspective. Start at C and place your ruler in a diagonal position and draw a line from C to B. Then draw a diagonal line from A to D. Move to the right side of the building and draw a diagonal line from A to F and another from B to E. The X's should look like those in the diagram.

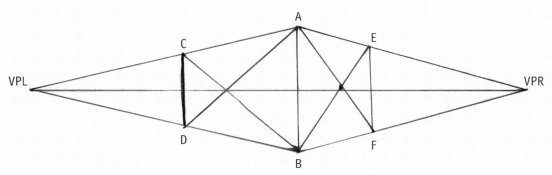

Step 3 for Drawing a House

Step 4. Now that you have established the centers of each side of the building, you are ready to make the peak of the building and the roof line. Draw a vertical line through the center of the right X, and extend it as high as you want the peak of the roof. Mark this line G. I extended this line the same distance as the center of the X to the top of the building. The line through the left X (H) is shorter and really does not have to be extended as much as line G because that side of the building appears shorter when in perspective. However, the length of line H will be determined by a line drawn from VPL to the top of line G, so think of line H as extending into infinity. Notice that when the line from VPL to G is extended, it passes through a point on a line drawn perpendicular to the horizon line from VPR. That point is called the inclining vanishing point (IVP).

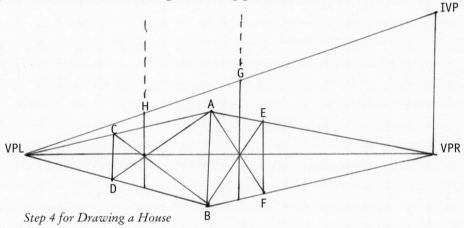

Step 4 for Drawing a House

Step 5. Finally, draw a line from A to G, another line from G to E, and one more from C to H. Those lines will outline the roof of a building drawn in perspective.

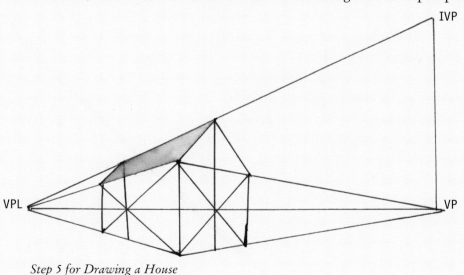

Step 5 for Drawing a House

Charlie's House
Marcia Moses, 22 × 30 inches

The painting *Charlie's House* is a good example of how two-point perspective can be used to achieve proper artistic design.

Notice how the rooftop and front foundation lines extend toward the same vanishing point to the left, while the back roof and side foundation lines extend to a vanishing point to the right. This creates the illusion that the viewer is looking at the house from its front right corner. The front and the right side of the house both appear smaller as they extend away from the viewer's eye. This creates depth and indicates that the painting is in perspective.

Mastering Color

"Color! What a deep and mysterious language, the language of dreams."

—PAUL GAUGUIN

Both the yellows and purples boldly hold their color against the flash of orange in this collage. Each makes the other more intense.

COLOR HARMONY & CONTRAST

WORKING WITH WATERCOLOR may at first seem strange and difficult, especially if you are used to opaque media, such as oils or acrylics. The first and most obvious difference is the fact that most watercolor pigments are transparent. This means that you must decide from the very beginning where the areas of white will be in your painting. You won't be able to paint over colors with white the way you can with other media.

To produce a successful watercolor painting, an artist must avoid the areas to be left white and apply the lightest washes first, gradually working toward darker washes. Try to cover large areas fairly loosely in the early stages of the painting, not worrying so much about where the pigment is going. Worry less about detail and more about creating a background and a foreground. Add that tighter detail toward the end of your painting.

To maintain color harmony throughout your painting, you'll need to remember how to repeat colors, glaze and layer colors, mix exciting colors, and work with specific color properties.

Making a Painting Work

Repeating Colors

How often do you look at a painting and see an area of color that doesn't seem to fit? A group of trees could be painted in a green that may seem so out of place in a painting that it appears unrealistic. A river could be painted in a blue so discordant that it overwhelms the artwork. A flower painted in a purple that jumps out of the bunch could take away from the unity of a painting.

The remedy to this problem is simple: introduce more of the foreign color to the rest of the painting. If you place the discordant color in three different spots in a painting, you'll reestablish unity in that artwork.

Pen & Ink

A few fine calligraphic lines made with a color that will work well with other colors in a painting can also tighten up a disjointed color arrangement. Use a #4 or #6 liner brush or pen and ink. It is important to use just one color for these lines or you'll run the risk of adding to the confusion. If you use ink, a fine spray of water quickly after the ink is applied will soften the lines and create some interesting feathering effects.

In the painting *After Thought,* I added some pen and ink for effect and it tied the painting together.

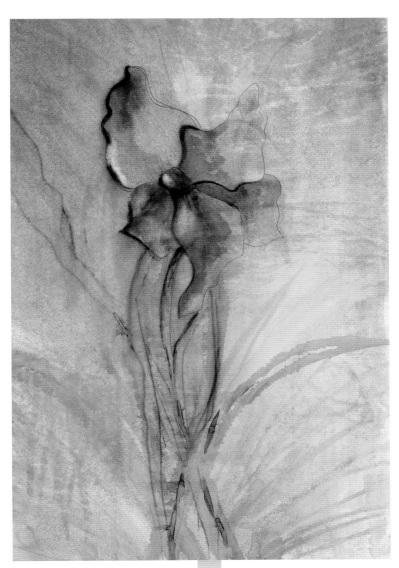

After Thought
Marcia Moses, 11 × 15 inches

Glazing & Layering Colors

Glazing

In the glazing process, each color is dried before applying the next color. The drying sets the glaze into the paper and causes it be unaffected by the next color applied. This allows the previous color to shine through. In the accompanying illustration, the yellow shows through the colors glazed on top of it and creates a natural glow.

Glazing

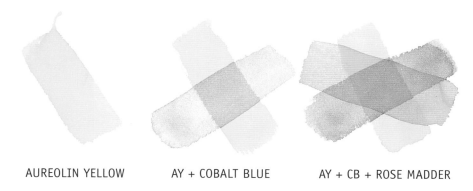

AUREOLIN YELLOW AY + COBALT BLUE AY + CB + ROSE MADDER

MULTIPLE GLAZES

Multiple layers of glazing will retain the same colors, although the values of those colors will be increased. This glazing process consists of nine layers of paint. With each layer, the center becomes stronger and darker.

Multiple Glazes

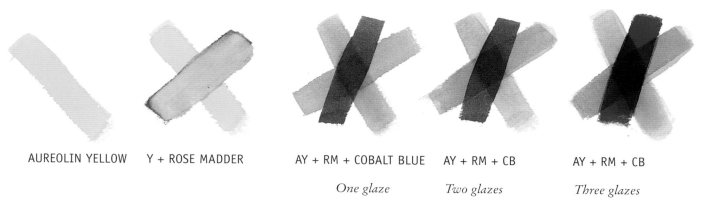

AUREOLIN YELLOW Y + ROSE MADDER AY + RM + COBALT BLUE AY + RM + CB AY + RM + CB

One glaze *Two glazes* *Three glazes*

GLAZING TO CHANGE SAME-COLOR VALUE

Values of a color can be changed by using the glazing technique. This is an example of glazing with the same color to produce a value change. The areas of the X's shown here are a darker value because they benefit from two glazes of the same color. This can be done with all colors.

Glazing to Change Same-Color Value

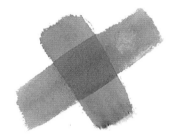

COBALT BLUE + COBALT BLUE

ROSE MADDER + ROSE MADDER

Layering

When color is layered, each color is painted on without drying between the layers. Thus, the paint is allowed to mix on the paper. That results in a blending of colors because the previously applied color was not allowed to set. The bottom color will not show through the colors applied atop it as clearly. The result of layering can still be luminous, but usually not as luminous as a glaze.

Layering

AUREOLIN YELLOW

AY + COBALT BLUE

AY + CB + ROSE MADDER

Viewing Results in Paintings

GLAZING

The backgrounds for the paintings *Pears and Apples* and *Pansies* are both examples of glazing technique. However, the flowers and fruits themselves are examples of layering technique.

For *Pansies,* three or four colors are used in about a dozen glazes, but the luminosity comes through. The glazes are applied in very watered-down washes. The glazes include aureolin yellow that's dried, then rose madder that's dried, which creates an orangey look. Then cobalt blue, the third complement, grays down the orange; it's dried, and so on. The colors become progressively darker.

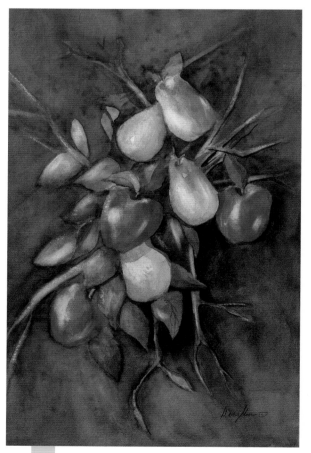

Pears and Apples
Marcia Moses, 15 × 22 inches

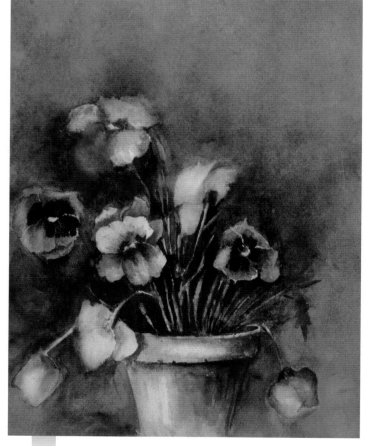

Pansies
Marcia Moses, 11 × 14 inches

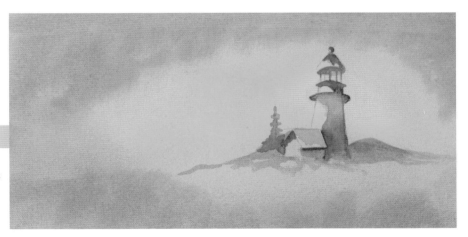

Luminous Light
Marcia Moses, 11 × 14 inches

LAYERING

For the painting *Luminous Light*, I first very lightly sketched in the lighthouse. (Remember it's important to keep any sketch light if you plan to use yellow since the pencil marks could show through.) I wet the paper and added aureolin yellow in a circular motion around the top of the lighthouse. With the paper still wet, I immediately went around that circle with a light-value mixture of rose madder, lightly touching on the yellow so that it would spread into it. Then I quickly applied a layer of cobalt blue around the bottom and top of the painting, allowing those colors to blend. After these layers dried, I used a mixture of all three colors to create a dark tone to provide the slight detail and shadows of the lighthouse.

In the painting of *Fishing at Sunset*, I began with a light-value yellow ochre base and immediately applied rose madder over the top, which created a burnt sienna look. To create unity or balance in the painting, I added a third layer of cobalt blue at the very top to create depth. Then I added cobalt blue to the rocky coast to help balance the sky and to take the viewers out to sea.

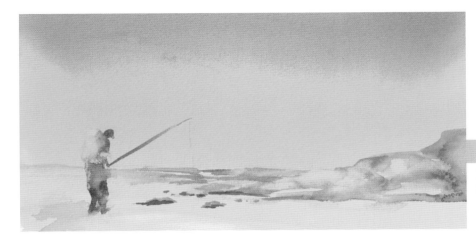

Fishing at Sunset
Marcia Moses, 11 × 14 inches

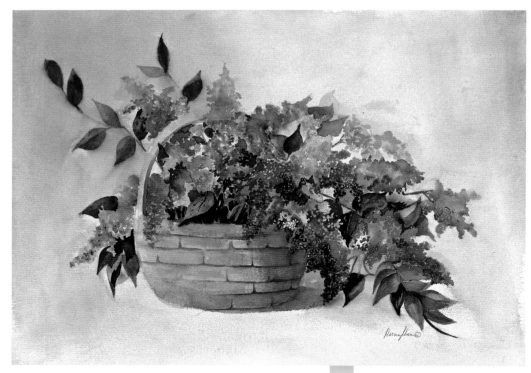

Basket of Lilacs
Marcia Moses, 22 × 30 inches

GLAZING TO CHANGE COLOR VALUES

Notice the technique of glazing to change same-color values in the paintings *Hydrangeas in Glass* and *Basket of Lilacs*. The painting *Hydrangeas in Glass* uses the same violet all through the vase, with the white areas of light left open. But some places, such as the bottom of the vase, show different values of that Holbein permanent violet. One side of the vase is very dark, but some violets still reflect in it. The painting *Basket of Lilacs* has three or four glazes of cobalt blue.

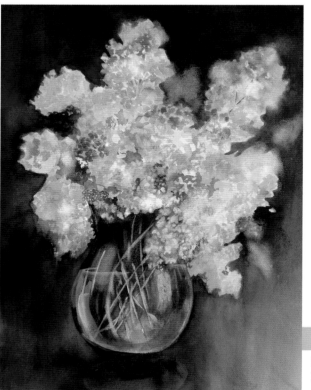

Hydrangeas in Glass
Marcia Moses, 22 × 30 inches

Painting Light to Dark

Glazing is the technique of applying layers of paint without disturbing each layer. This is accomplished by drying each glaze before applying another. The glazes can either be the same color or different colors. Although there are situations when glazes of opaque colors can be applied, beginners most often will want to glaze with transparent colors. This allows each glaze to show through glazes that are applied after it. If I apply a layer of yellow and then apply a glaze of blue on top of it, I will be able to see the yellow glaze through the blue glaze.

Remember, glazing differs from layering. When layering, the applications of paint are not dried between each layer. So, the colors mix on the paper as each layer that is applied disturbs the previous layers.

For example, if I applied a yellow layer, and then layered blue on top of it, I would come up with a mixture of yellow and blue, which would be green. When I glaze these same two colors, I will create a different green because I have preserved the dry background layer by not disturbing it. In the painting *Look Through My Window*, numerous glazes were used on the flag each time to make the reds and whites glow.

> *"Contrasting color temperatures are as important as value contrasts."* —ZOLTAN SZABO

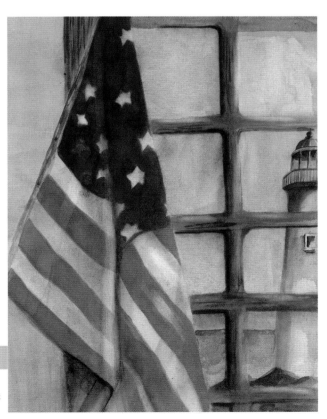

Look Through My Window
Marcia Moses, 22 × 30 inches

Common Properties of Watercolors

All watercolors possess one or more of these properties. Being aware of what properties a color has will let the artist know what the color will do on the paper.

The properties of color also affect how colors will react when mixed with each other. For example, if you mix two colors that both have a granulating property, you are going to get a very granulated color. They will separate from each other.

You'll discover your own favorite color mixes. For a transparent look with luminosity, I like to use a mixture on wet paper of cadmium yellow light + rose madder + cobalt blue. For a beautiful dark green, I use a mixture of marine blue + burnt sienna.

transparent a color that allows other colors and the light of the paper to show through

semitransparent a color that allows a limited amount of other colors and the light of the paper to show through

opaque a color that allows no other colors or light from the paper to show through

easy lift a color that can be removed easily from paper

hard lift a color that is difficult to remove from the paper without ruining the paper's surface

staining a color that cannot be totally removed from the paper

nonstaining a color that usually will not be permanent on the paper

semistaining a color that will stain the paper, although it can be partially removed

intensity a color with purity or brightness (rose madder, lemon yellow, and cobalt blue are intense colors)

granulating a color that will separate into granules when placed on paper

Selected Color Guide

Here is a guide to the colors I use the most. In parentheses are my notes about color permanency, the relative length of time a color will last on paper before it begins to fade. This characteristic often is defined by a paint manufacturer in a star rating, with three stars usually indicating the longest life.

rose madder transparent, semistaining, hard lift, intense (absolutely permanent)

opera transparent, nonstaining, intense, granulating (moderately durable)

crimson lake transparent, nonstaining, intense (permanent)

vermilion semitransparent, nonstaining (absolutely permanent)

aureolin yellow transparent, nonstaining, easy lift (absolutely permanent)

yellow ochre opaque, nonstaining (absolutely permanent)

gamboge nova transparent, nonstaining, easy lift (permanent)

cadmium yellow light transparent, nonstaining, intense (absolutely permanent)

MaimeriBlu golden lake transparent, staining (absolutely permanent)

burnt sienna transparent, nonstaining, granulating (absolutely permanent)

Yarka emerald green semitransparent, staining

cobalt blue transparent, nonstaining, easy lift, granulating (absolutely permanent)

cobalt blue hue transparent, nonstaining, granulating (absolutely permanent)

cerulean blue semitransparent, nonstaining, easy lift, granulating (absolutely permanent)

ultramarine light transparent, nonstaining, easy lift, intense, granulating (absolutely permanent)0

ultramarine deep transparent, nonstaining, easy lift, intense, granulating (absolutely permanent)

marine blue transparent, nonstaining, easy lift, intense, granulating (absolutely permanent)

Mars violet semitransparent, nonstaining, granulating (permanent)

Yarka red violet semitransparent, staining (absolutely permanent)

raw umber transparent, nonstaining, granulating (absolutely permanent)

neutral tint transparent, staining (permanent)

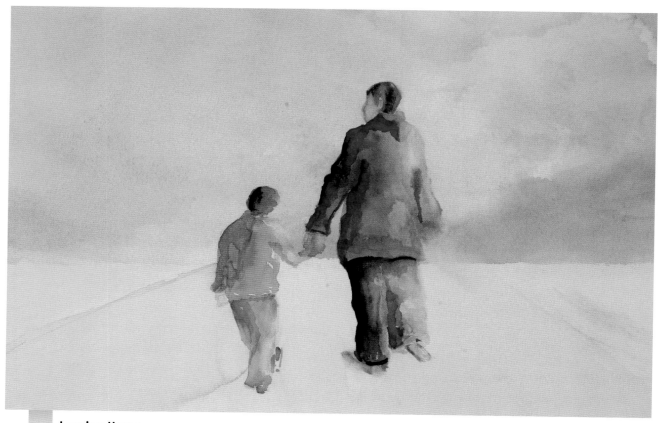

Leaving Home
Marcia Moses, 15 × 22 inches

Amazing Color

Color has so many dimensions that no individual can possibly know all the ways it will react in a painting. Watercolor demands an ongoing learning process that we cannot complete in a lifetime. In over twenty years of teaching and painting, I've been able to touch on only a small part of what this wonderful medium has to offer. With so many possibilities for combinations of color, every time I take brush to paper I feel that I am discovering new ways for color to bring a painting to life. In my life as an artist, I've never ceased to be amazed by color dynamics. My hope is that you can feel the same excitement while playing with color.

In fact, color itself can be used to create a mood of excitement, or a peaceful mood, for that matter. Combinations of color can be designed to work in any of what artists call *color keys*. A high-key painting makes use of exciting, brilliant colors. A low-key painting uses muted, subdued colors. A middle-key painting is neither entirely high-key nor low-key, but contains colors from both.

Warming Up & Cooling Down

As you can see, the color wheel has a cool half and a warm half. Although some yellows, reds, and blues may be on the warm side of the wheel, they also can have some cool properties. For example, aureolin yellow is a cool yellow because it has a bias toward blue. This is why it is so important to know the properties of every color you use and how that color will react with other colors.

Red is the dominant warm color on the wheel. To remember this, think of red in terms of the heat of the red coals of a fire. Blue is the dominant cool color. Think of blue ice, sky, or water.

The coolest color on the wheel is violet, which is quite useful for creating dark hues. Black, of course, could be used to darken a color, but most blacks are stagnant colors, which will tend to create muddy, dead hues. Instead, to keep our colors bright and cheery, we can use violet to create a darker shade.

An individual color can be changed to a tint, or a lighter value of itself, by adding water. A color can be changed to a tone, or a grayed-down value, by adding the color's complement. It can be changed to a shade, or a darker version of itself, by adding violet, the darkest color on the color wheel.

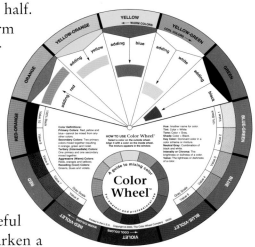

Color Wheel

***Tint** = Rose Madder + Water*

***Tone** = Cobalt Blue + Complement*

***Shade** = Aureolin Yellow + Violet*

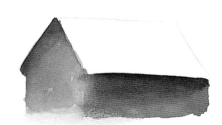

Barn in deep reds.

Red barn with purple background.

Mastering Color **51**

Color Combinations

Here are a few of the many combinations available to an artist. For your convenience, I'll refer to these colors with the color abbreviations noted in the box at left.

In each color combination below, I took three colors and first painted them adjacent to each other on a piece of paper (A), allowing them to mix at their edges.

Next, I mixed all three colors in equal parts on my palette and then applied them to paper (B). Finally, I mixed the first two colors and a small amount of the third color on the palette and put the resultant color on the paper (C).

What this exercise shows is that the same combinations of colors will result in different hues when mixed on paper than they will when combined on a palette. We can also see that the same combinations mixed on a palette can result in a variety of different colors, depending upon the amount of each color used.

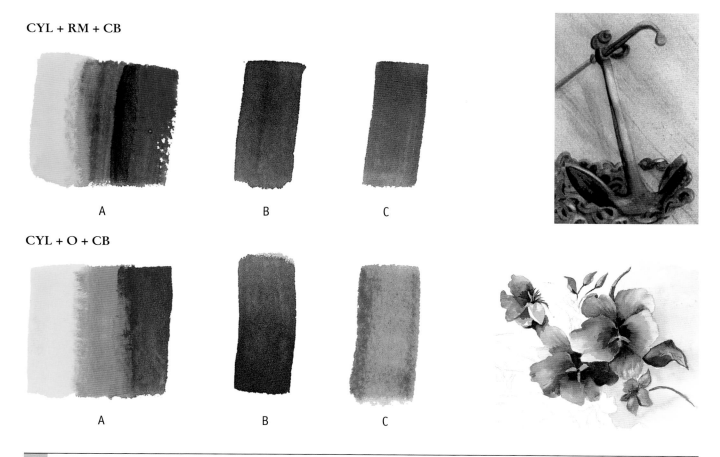

CYL + RM + CB

A B C

CYL + O + CB

A B C

CYL + BS + MB

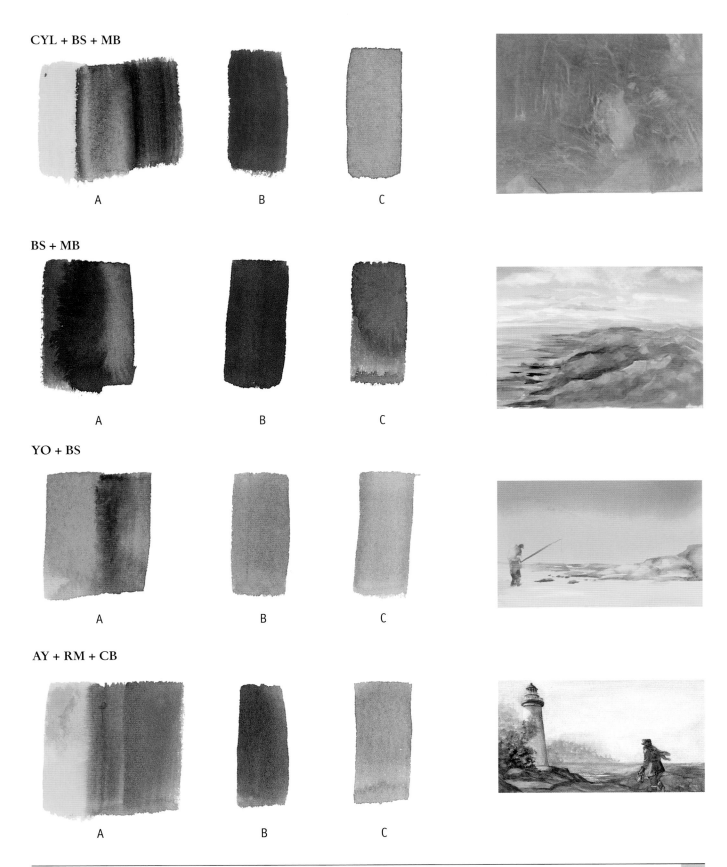

A B C

BS + MB

A B C

YO + BS

A B C

AY + RM + CB

A B C

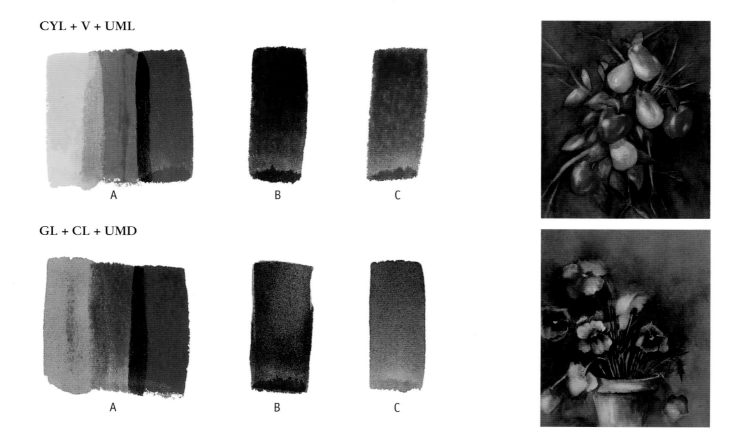

CYL + V + UML

A B C

GL + CL + UMD

A B C

Mixing Exciting Colors

Knowing how color works and what to expect is an essential part of the painting process. Every color has its own unique properties. Some are transparent; others are opaque. And a number of other important qualities, such as granulation, can either make or break a painting.

My use of a fairly limited palette allows me to become familiar with the colors I am using. When I introduce a new color to my palette, I play with it and study its properties so that I know what I am working with and how it will react on the paper and mix with other paints. Simply playing with and mixing colors can give an artist a better understanding of how a particular color will work.

I cannot stress enough the importance of studying the properties of color and experimenting with them yourself.

A new paint I experiment with sometimes may list "easy lift" as one of its characteristics, which means that the color will easily lift off the paper with water. Yet another stated property of the same color is that it is a staining color. Reading this, I am somewhat skeptical that it can be both, so I try the paint out myself. Sometimes I am right to feel this way because the staining color really does not lift off the paper as much as I would like, and it certainly is not lifted easily. Other times, however, a staining color will lift off the paper surprisingly easily. I would not have been confident about that, however, had I not experimented first.

Most paint manufacturers offer general guidelines to help artists determine the properties of the watercolors they produce. Some go the extra mile and give artists an extensive list of the properties of all their colors, even including the performance and stability of each individual color.

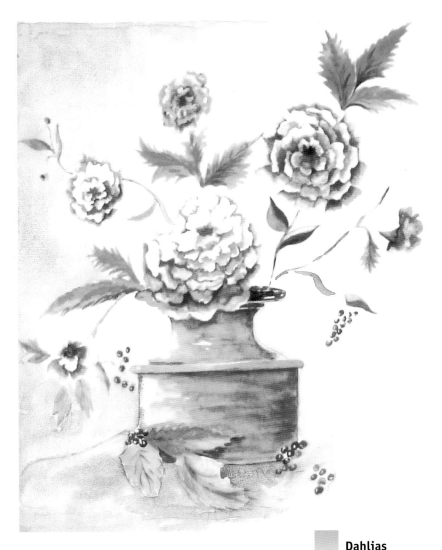

Dahlias
Marcia Moses
8¼ × 10¾ inches

LIMIT YOUR PALETTE

While it's tempting to dip into twenty different colors spread around your palette, this approach usually leads to muddy work.

Limit your colors to just two or three, particularly in the early stages of a painting. Your subject will dictate which ones to choose. I find that for such subjects as buildings, landscapes, and flowers, starting with washes of earth colors, like raw sienna and burnt sienna, plus a little ultramarine or cobalt blue, depending on the atmosphere you want, gives a harmonious foundation for your work. Carefully introduce more intense colors later, if necessary.

The Color of White

The spectrum has an infinite number of colors, and white contains them all.

Because of this, dozens of different shades of white exist, and no single one of them is the "real" white. In fact, a number of different shades of white can be combined in a single painting that, even by its name, *White on White*, illustrates a technique.

Painting white on white is usually combined with leaving white space on your paper and using masking to preserve whites. I use transparent colors, diluted with a lot of water, so they have a very low value.

For example, if you paint a shadow with cobalt blue that has been diluted with water, the color you'll come up with will read white in the painting. *White on White* contains a sampling of colorful whites that work together subtly.

You will notice that I did add some dark colors, in the vase and mirror. This gives the painting some contrast, without overpowering its white-on-white scheme. Here are a few diluted colors that will "read" as white in a white-on-white painting.

White on White
Marcia Moses, 15 × 22 inches

These colors can appear "white."

In the painting *Sailing*, the sails on the boats illustrate a white-on-white technique. The soft tints of yellow, blue, and red give the shadows a believable look of sail-cloth and add dimension. You can almost feel the wind filling the sails.

The yellow on the front of the sail in the foreground gives the impression that sunlight is hitting the cloth, giving it a warm glow against the cool background.

For the painting *Quiet Place*, I used shades of white for the shadows on the chairs. For contrast in the background, I sponged and negative-painted the foliage.

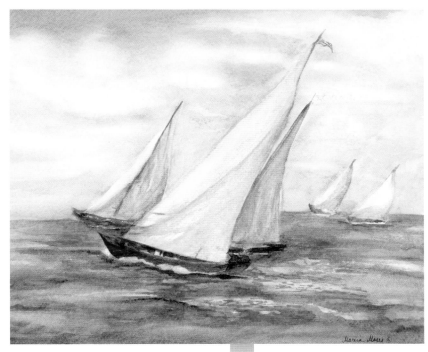

Sailing
Marcia Moses, 11 × 14 inches

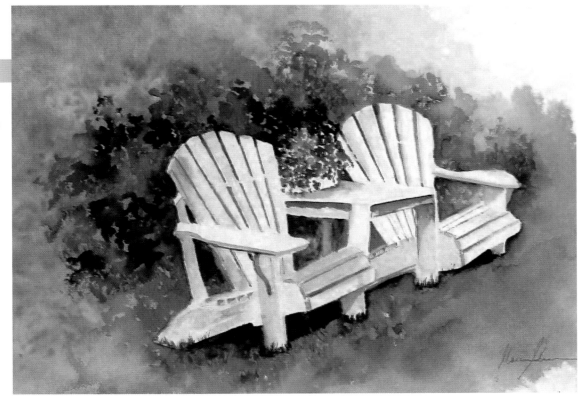

Quiet Place
Marcia Moses
22 × 30 inches

Techniques in Action

"Texture adds variety and visual stimulus to the surface of a painting."

—BRITTON FRANCIS

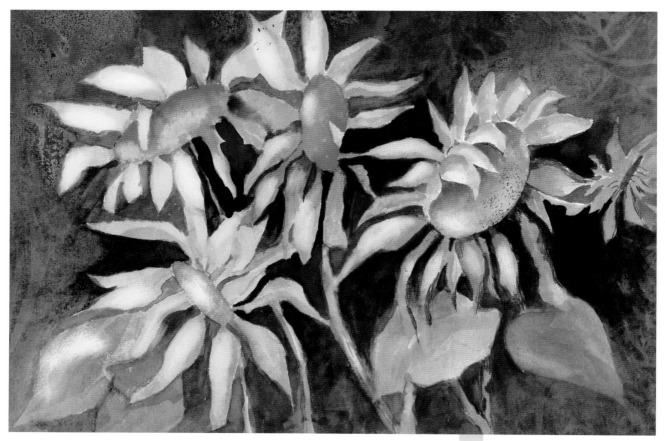

Sunflowers
Marcia Moses, 15 × 22 inches

CREATING BACKGROUNDS

A GOOD BACKGROUND can either make or break a painting. You can have a beautiful picture, but if the background does not complement the foreground, it can be confusing to the viewer.

Backgrounds can have texture or be smooth, be glazed or layered, or be created using a combination of such techniques.

A background can be applied at any time while painting. You can plan ahead for a background by designing the composition with a firm idea in mind of where light and dark objects will exist in your painting. Or you can be spontaneous, by throwing paint onto paper, for example, and then using your imagination to determine the result.

Whichever method you use, backgrounds perform pretty much the same tasks in a finished painting. They can add a feeling or mood to a painting. They can make a painting warm or cool. A background

can create depth by moving objects forward or making them recede. A highly textured background also can add depth and create interest that does not detract from the painting's focal point.

The types of background are numerous. You can create various kinds of backgrounds by glazing, layering, or spraying on color, or by using cornstarch, salt, tissue paper, or sponges.

Layering for a Three-Color Background

Step 1 For this three-color (triadic) layering technique, first wet the paper with a 1-inch flat brush.

Make a large puddle on your palette of MaimeriBlu golden lake. This is a strong yellow, so add enough water to make a mid-value wash. Paint a wash on the wet paper using a left-to-right stroke, adding more paint as needed to get to the bottom of the paper.

First layer: MaimeriBlu golden lake.

Step 2 Make a large puddle on your palette of Holbein rose madder. While the yellow is still wet, paint a layer of the rose madder on top using the same brushstokes. The two colors will mix on the paper and produce a beautiful transparent orange color.

Second layer: Holbein rose madder.

Step 3 Repeat steps 1 and 2, this time using a cobalt blue hue. The result is a wonderful grayed-down background, almost a sienna, that you can use for a landscape, portrait, or still life. While the hint of blue is evident, the red and the yellow colors show through as orange because of the transparency of all three colors.

Third layer: Cobalt blue.

Giving Layered Backgrounds Texture

This textured background was created with plastic wrap, waxed paper, salt, sponging, and spattered, poured, or dropped paint.

If you choose to add more texture to this background wash, you can use a number of common household items to accomplish your goal. However, you must make sure you begin these texturing procedures while the last wash is still wet.

PLASTIC WRAP

Lay the wrap on the wet paint and move it around to create different designs on the paper. Experiment with all kinds of shapes, and then allow the paint pattern to set up for about 10 minutes before lifting the wrap off. Practice by making a mix of marine blue and burnt sienna. Paint a line resembling a log. Take a small piece of plastic wrap and stretch it lengthwise and then lay it down on your log. The wrap, when removed, will leave a mark that resembles bark.

SALT

When a watercolor first begins to lose its shine, throw salt on it to pick up paint and create controlled textures, such as snow, ice crystals on a window, flower shapes, and a variety of other effects.

Decide what size of salt crystals you want to create the desired texture. Crystals of table salt are small, and thus will absorb small amounts of paint. Kosher salt is a little larger and flatter; the crystals will create larger blossoms. Sea salt is composed of clumps of crystals stuck together, and its resulting surface area makes it ideal for absorbing large amounts of paint. Rock salt is the largest, and will absorb the most paint. So be careful when choosing a salt. Make sure that its absorption qualities match the design you have in mind for your painting.

If no salt is at hand, sand is sometimes a handy substitute. It contains up to 60 percent salt, if it comes from a saltwater source, such as the ocean.

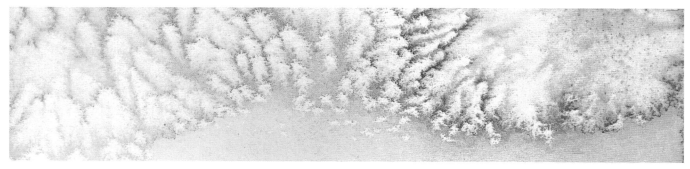

Textured background created with sea-salt crystals.

CORNSTARCH

To make a background for that beach scene, try mixing cornstarch and water. Paint the mixture on your paper, drop paint into it, and the paint will begin to mix with the cornstarch and water in a way that you can carefully control. If you turn the paper in different directions, the mixture will create swirls, milky textures, and other beautiful designs. This also is a wonderful way to encourage your creativity to flow.

The muted effect can be soft and romantic and suggest flowers, trees, or mountains viewed at a distance or imperfectly seen.

Cornstarch and water can create swirls and milky textures.

TISSUE PAPER

For three-dimensional textures, lay a piece of tissue paper on top of gesso that has been applied to the paper. You can crimp the tissue in places to cause ridges, but it really is unnecessary. The gesso will automatically pull at the tissue as it dries, causing those ridges to form, creating landscapes of its own.

Drop some watercolor randomly around the painting and watch the texture of the tissue take on different shapes. Let this dry and do a painting on top of this textured background. Use your imagination to create whatever it is you see in this background.

Tissue paper, with or without crimps, can create ridges and other designs.

SPONGES

It is unbelievable how many different types of sponges are on the market and how readily available they are. I have found some really interesting and useful sponges, in places other than art stores, that make great textures.

Cut kitchen sponges into shapes and apply paint to them with a brush so that the crevices are paint-free. Then they can be used as stamps to create, for example, pebbles in the sand or a stone wall. You can even use a utility or X-acto knife to cut out large shapes and create rocks or bricks.

I found these round sponges (shown right) at a department store in the paint section. They are used to create texture on interior walls, but an artist can also use them to make blossoms on a lilac or a stone wall, fashion unique backgrounds, shape pebbles, and create so many more fun things.

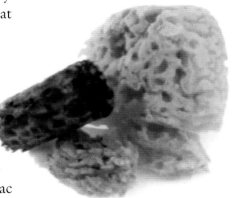

Sponges of all kinds can help create desired textures. Cut them up to create your own stencils.

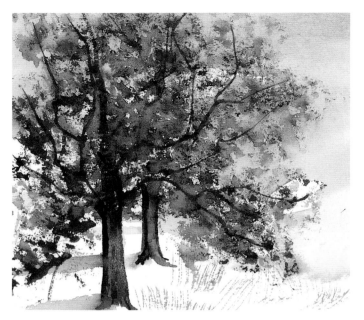

Sponged tree leaves and sponged land.

Sea sponges are effective for creating trees and foliage, grass, and other landscape objects that an artist wants to portray in soft-edged shapes, rather than in fine detail.

For example, sea sponges can be used to paint patches of flowers, without creating the need to detail each individual flower.

More Leaf Shapes One of the fun things to do with texture is to gather leaves from a tree and paint or sponge the back side of them with your watercolors. Then press them on your watercolor paper to achieve a leaf image. They become natural stamps.

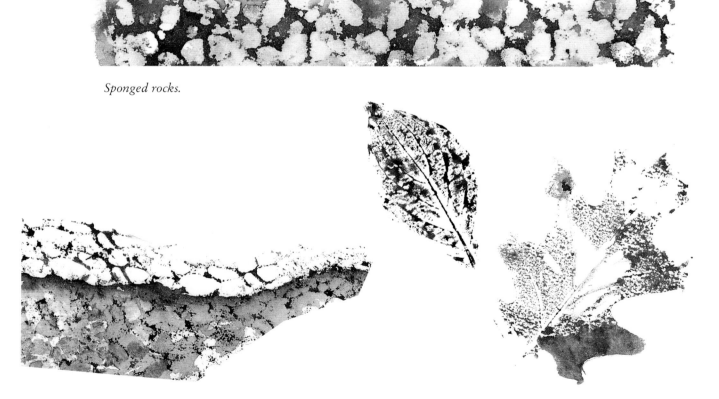

Sponged rocks.

Jetty created with a round sponge.

Stamping with leaves.

Texture That Adds Dimension

The background of the painting *The 19th Hole* was done after I masked out the golf clubs and all other objects in the painting. I applied three layers of color in succession: cadmium yellow, vermilion, and ultramarine blue. The ultramarine is a granulating color, and it created a texture for the background. I then spattered vermilion with a toothbrush to give more texture and depth to the painting. I removed the masking and painted the detail work in the golf bag and clubs. Finally, I painted the shadows, which added contrast to the completed work.

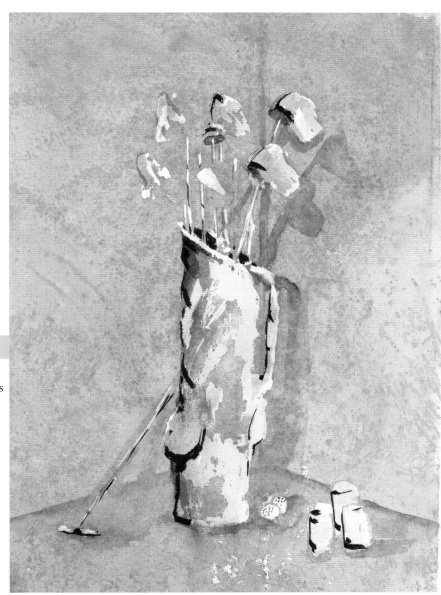

The 19th Hole
Marcia Moses, 11 × 14 inches

A toothbrush is a handy tool for creating texture in the background of your painting. It can even be used for adding stipplinglike details to give an object dimension.

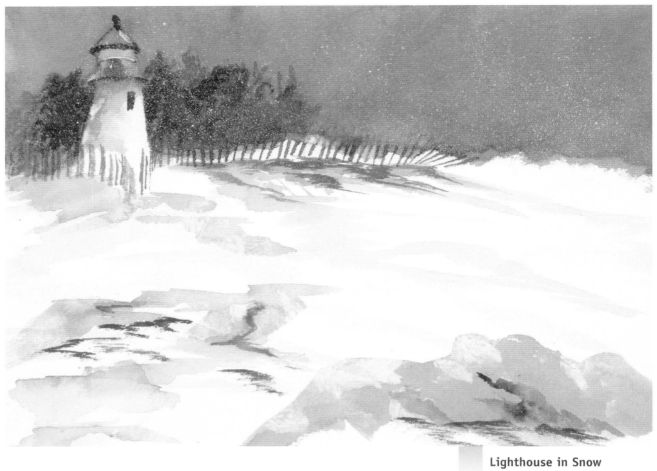

Lighthouse in Snow
Marcia Moses, 11 × 14 inches

EFFECTIVE BRUSHSTROKES

"The artist must say it without saying it."

—Duke Ellington

All brushes have their own unique characteristics, and knowing the capabilities of each can make the difference as to whether your painting appears believable. Remember, however, that no matter what brush you use, it should be broken in until you feel comfortable with it. Brushes are something that few artists like to share, because once used, they begin to fit a hand like a well-worn pair of shoes fit the feet.

These are just a few examples of what you can do with various types of brushes to get specific effects. For example, all brushes will not scumble in the same manner. Try a variety of brushes to discover what strokes you are comfortable with. In addition to the strokes shown here, make up some of your own and apply them to a painting..

1-INCH FLAT BRUSH

This brush is great for washes, glazes, layers, and large paintings.

Holding a 1-inch flat brush.

1-Inch Flat Brushstrokes

WASHES

HORIZONTAL LINES

SWIRLS

VERTICAL LINES

FLAT STROKES

SCUMBLING

BRUSH LOADED ON EDGES WITH DIFFERENT COLORS.

¾-INCH FLAT BRUSH

Smaller than the 1-inch flat, the ¾-inch flat can get around the edges of an object with more ease than larger brushes. It's good for cut edges, small washes, and fine vertical lines in fences. This brush has a very controlled feel to it.

¾-Inch Flat Brushstrokes

WASHES

HORIZONTAL LINES

SCUMBLING

BRUSH LOADED ON EDGES WITH DIFFERENT COLORS.

SWIRLS

VERTICAL LINES

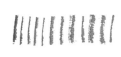

FLAT STROKES

½-INCH FLAT BRUSH

The ½-inch flat is useful for making small washes, painting around objects, and forming bricks or cedar shingles (shakes).

½-Inch Brushstrokes

WASHES

HORIZONTAL LINES

SWIRLS

VERTICAL LINES

Holding a ½-inch flat brush.

SCUMBLING

FLAT STROKES

BRUSH LOADED ON EDGES WITH DIFFERENT COLORS.

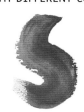

LINER BRUSH

A liner brush, such as a #2 round or a #4 round brush, is good for painting such small details as the branches of a tree, details on a house, small patches of grass, or calligraphic lettering.

Liner Brushstrokes

TREE BRANCHES

WINDOWS, ROOF SHADOWS

FLAT STROKES

SCUMBLING

CALLIGRAPHY

GRASSES

#4 ROUND BRUSH

A #4 round brush can be used as a rigger to create detailed strokes by holding it at the tip and allowing the brush to flow at its own pace.

#4 Round Brushstrokes

HORIZONTAL LINES

VERTICAL LINES

Position for holding the #4 round brush.

SWIRL

SCUMBLING

FLAT STROKES

CALLIGRAPHY

HAKE BRUSH

The hake brush can be used in place of the flat brush for washes, glazes, and painting a rippled effect on water.

Hake Brushstrokes

WASHES

SCUMBLING

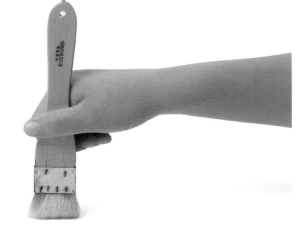

Holding a hake brush.

RIPPLES & WAVES

#18 Round Brush

The round brush is fun and useful for painting around objects. Because it has a point, it will allow an artist to apply a lot of paint in a specific area while not disturbing the objects being painted around. This brush offers great flexibility when working in a large area.

#18 Round Brushstrokes

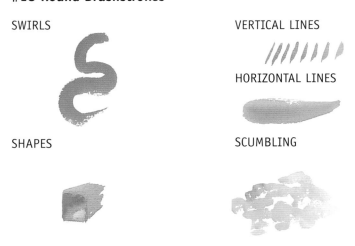

SWIRLS

VERTICAL LINES

HORIZONTAL LINES

SHAPES

SCUMBLING

Holding the #18 round brush.

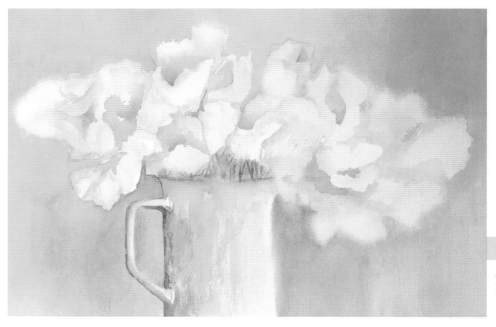

A Touch of Vermilion
Marcia Moses, 15 × 22 inches

The hard and soft edges, or lost and found edges, maintain the petal shapes and suggest the delicacy of the flowers.

Getting an Edge

There are different varieties of edges that watercolor painters should consider for their compositions. For the best effects in watercolor, you need to plan ahead for the treatment of edges.

Hard Edges Hard edges can be created by painting directly on dry paper.

Soft Edges Soft edges are achieved by painting on damp paper. The paper is not saturated; this possibly would cause a puddle of color to possibly spread in all directions. Instead, apply paint to paper at the moment just before the water loses the shine.

Lost and Found Edges These edges that are hard or soft in some places, but nearly nonexistent in others, can be painted on dry paper. But then, use a damp brush to loosen some of the edges, thus creating a push-pull effect. A push-pull effect can give an object dimension. If you soften or even lose some edges of a tree, for example, and leave others edges hard, it will appear to be round instead of flat.

Watercolor artists have a great many choices about how to use this versatile medium. Sometimes a subject simply demands a wet-into-wet approach with soft, feathery edges that suggest rather than precisely define objects. Other times, hard, precise edges are chosen. Frequently, the most interesting watercolor paintings use both kinds of edges to give dimension and focus to their subject matter.

To practice these concepts, choose any subject you want and try painting it using all (or primarily) wet-into-wet passages, with soft, undefined, or lost edges. Then try painting the same subject again, using hard edges. Here are some examples that will be helpful in understanding the differences in the edges.

The painting *A Touch of Vermilion* (shown on p. 70), for instance, has many hard and soft edges. My intention in this mono-chromatic painting was to emphasize the whites. Therefore, I needed to make the flowers stand out. Using a variety of hard and soft edges on the flowers created movement and gave dimension to each flower. Where I softened the edges, that part of the flower appeared to move back into the distance. Where I left hard edges, those edges came forward and produced a push-pull effect. I used vermilion and its complement, cobalt blue. Try this technique using other color combinations.

HARD EDGES

SOFT EDGES

LOST AND FOUND EDGES

Creating edges for various effects.

Painting Fences and Walls

Fences or walls are visually interesting in their own right, but they also can be used to help lead a viewer through a painting. Your artwork can be designed in such a way that the fence or wall will either make a statement—"I want to be looked at"—or can be a guide through the work. In the accompanying illustrations, I will show you techniques, brushes, and brushstrokes that an artist can use to create fences and walls that will add not only to the contents of a painting but also to its composition.

WHITE PICKET FENCE

Use a ½-inch flat brush, loaded with a mixture of marine blue and burnt sienna and held in a perpendicular position (see page 73). Make a series of marks in a line on the top third of your page. These marks are tapped in with no bend to the bristles; they're not pushed in. If you push and press too hard, the bristles will split and the marks will not be distinct and separate. Instead, you'll get blotches of paint between the marks.

Fence strokes (for painting sky that will show through the fence).

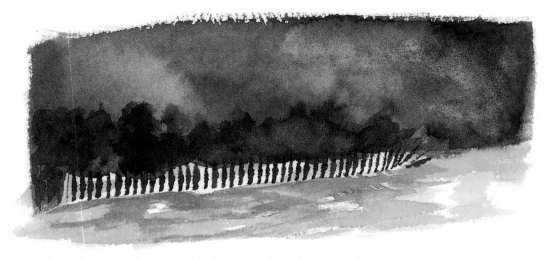

Finished fence with trees and dark, cloudy sky in background.

With your brush again loaded with the same mixture, begin painting in the sky. Move your brush down to the area where the fence posts are. The lines that you painted are the background of the fence. The white between the lines is actually the fence. This is called *negative painting,* or painting behind an object to make it come forward. Now paint across the top of the fence, randomly coming down into the fence to create the illusion of distance.

While the paint in the sky is still damp, lift out some clouds with a tissue at the top of the paper and you will be left with the illusion not only of the clouds but also of trees behind the fence. After adding a little water to the mixture to give it a lighter value, add to the foreground some color that reflects the sky. Also add some shadows on the fence with a light glaze of burnt sienna.

To give the composition more interest, consider other options before you begin the fence. Try different color combinations. You can add a house, barn, tree, lighthouse, or other objects that would be visually stimulating. But remember, put these objects in before you do the fence because the technique of painting the fence requires that you very quickly paint the sky behind it. Once you do, the opportunity to add still more objects to your design may be lost.

Position for holding the ½-inch flat brush for painting fences.

Completed scene with house and fence.

BRICK WALLS

With the edge of your ½-inch flat brush loaded with burnt sienna, start making strokes in a flat brush position. At least half the length of the bristles, perhaps even two-thirds, should be touching the paper. Paint each brick about ¼ inch down. Each brick's width will be the size of your brush. Continue painting bricks in a line as long as you want the wall to be.

Keep in mind that if you are painting a wall that is receding, it must conform to the rules of one-point perspective. Each brick, and thus the wall itself, must be painted smaller as it recedes.

Moving on to the next row of bricks, use the same method but stagger the bricks. When the bricks are dry, paint a wash of cobalt blue over the entire wall. This will fill in the white spaces in a gray tone.

Position for holding the ½-inch flat brush to paint bricks.

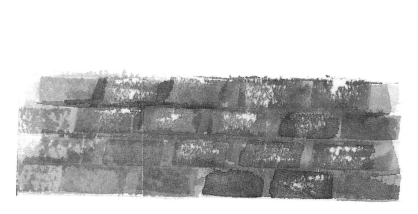

Darken some bricks using the #4 round brush.

Position for holding the #4 round brush.

After the paint is dry, you are ready to give the bricks some texture and highlights. With the sharp edge of a razor blade held in a perpendicular position, scrape the brick to give the wall a rough texture. You can also use a #4 round brush, loaded with a mixture of sienna and cobalt blue, to add a shadow under the bricks, which will give them dimension. Try different color combinations to get other unique effects. Paint lighter bricks and darker mortar, for example, or darker bricks and lighter mortar.

With the #4 round brush, you can give the bricks a slightly different look by darkening the colors of some of the bricks.

Using a larger flat brush, you can make larger bricks, which may be helpful if you are going to have the bricks recede in perspective

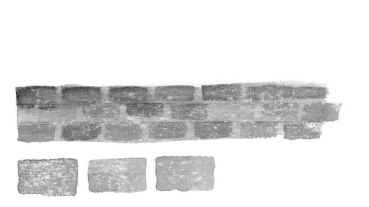

Strokes and finished wall of larger bricks.

Position for holding the 1-inch flat brush to make bricks.

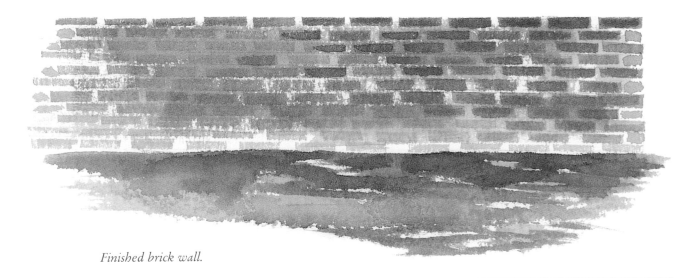

Finished brick wall.

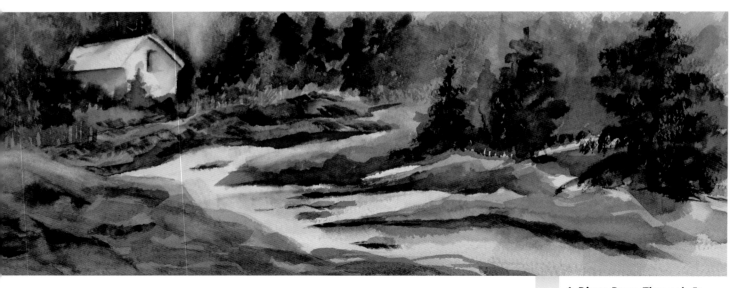

A River Runs Through It
Marcia Moses, 12 × 22 inches

CAPTURING NATURE

ONE OF THE NICEST PARTS of being an artist is having the ability to capture your interpretation of ordinary things on a piece of paper.

My favorite things to paint are landscapes and still-life subjects. In landscapes you can capture a feeling of the nature around you. Skies are beautiful hues of blue, orange, red, gray, and violet. Trees can almost jump out at you. Oceans can be angry or calm, foggy or clear. Shrubs and flowers, always colorful, can be happy or sad. Grass is green with hues of blue and yellow, and the combination of those colors can be inviting in a landscape. Structures that inhabit your piece of nature can take on textures that you can almost feel, or surfaces that are so soft they blend into their surroundings. Their windows can reflect the colors of the outside landscape or capture the effects of light streaming inside through their panes.

Let's look at different ways to use nature as a tool to produce a pleasing landscape.

Painting Trees

There are so many different species of tree that it would take an entire book to show them all, and it would be a pretty big book at that. Therefore, I chose a few of the more popular trees to give you a general idea of how to distinguish one from another. In painting in

watercolor, these different shapes of trees and flowers are unique; they can be painted as you alone perceive them, almost impressionistically at times. Fortunately, we all see things differently, or our interpretation would be the same.

Even trees that we see as similar, however, will take on different characteristics in our paintings because of our attempts to give our art depth. I may see a maple tree that looks like an oak tree in the distance and paint them the same way. But because one of the trees is in the distance, it will appear different in color. Atmospheric changes and perspective will cause the differences in color and clarity.

In the finished landscape *A River Runs Through It* (on p. 76), the tree in the foreground is very large because it's closest to the viewer. As we move back to the middle ground of the painting, the trees have receded and changed in hue and size. They are smaller and denser as they recede because of atmospheric change.

Deciduous and evergreen trees have distinctive shapes.

DECIDUOUS TREES

Deciduous trees, such as oak, maple, and birch, shed their leaves annually, and new foliage begins to grow in the spring. Look at the basic shapes of the trees you're going to paint. Draw only the outside shape of the tree, leaving the inside shapes to be created with color and texture.

Depending on the type of tree you'll be painting, you have a number of color and texture options. If you are painting an oak tree with a lot of texture in the bark, you can begin by painting a layer of burnt sienna and then adding a layer of ultramarine blue. Both colors are granulating and will create a beautiful textured brown. After applying those colors, take an old credit card, the end of a brush that has a flat surface, or the flat end of a razor blade, and scrape off some paint to create the texture and grooves of the tree bark.

Typical broadleaf tree.

Maple tree.

Birch trees in snow.

Here are some examples of ways to paint a few specific types of deciduous trees.

Broadleaf Trees Load the side of a ½-inch flat brush with a mixture of burnt sienna and marine blue. Wipe off some of the excess paint on a tissue to produce a dry-brush technique.

Place your hand in a writing position; the brush will almost be parallel to the paper.

Use a light motion and keep your hand still as you begin painting with the side of the brush. These strokes will not go down into the wells of the paper unless the brush is too wet. Instead, it will leave color only on the highest portions of the paper's surface. Try practicing this on scrap paper until you get the hang of it.

Keep in mind, trees are not round; they have various shapes and straggling branches. Some edges are hard and some are soft. To soften the edges, brush them with water. Add a small amount of Maimeri golden lake on the light side of the tree with a wet-into-dry method. Put a trunk on the tree and a few branches in the light spaces and you are finished.

Maple Trees Draw your tree shape with limbs but without leaves. Begin painting with burnt sienna, applying a wash over the entire tree shape. While the paint is still wet, add detail on the tree with ultramarine blue, creating the crevices, bark lines, and shadows of the tree that will give it dimension. Allow this to dry.

Load a ½-inch flat brush with a mixture of burnt sienna and ultramarine blue, and use the side of the brush to scumble paint in a leafy pattern around the tree. Give it some light areas with cadmium yellow light, and darken the bottom of the leaves with burnt sienna.

The techniques offered in this example can also be used to paint an oak tree, although the leaves have different shapes.

Birch Trees If you were painting a birch tree, you would first paint the tree bark shape gray and lift off some color to reveal the white of the paper. You can make a gray color by mixing complements, such as cobalt blue and a dab of orange and water. You would finish the tree, after it dries, with darker gray tones around the edges where the bark curls.

Apple Trees With a ½-inch flat brush, using a dry-brush technique, scumble a mixture of burnt sienna and marine blue to make the leafy portion of the tree. Remember to leave some whites to give the tree a feathery look, and leave room for the apples.

Next paint in the trunk of the tree. Use essentially the same mixture, adding more burnt sienna to give the trunk a brown color. Paint in the apples with a #4 round brush and rose madder.

With a clean, damp #4 brush, pull out the branches of the tree from the dark areas. Add a shadow under the tree and perhaps a few apples that have dropped to the ground so that they can be conveniently collected by passing children.

Dogwood Trees Draw the tree trunk and paint it with a mixture of burnt sienna and cobalt blue. Apply masking in clusters of dots randomly around the tree, four dots for each floret. Let dry. Paint in the leaves with a mixture of burnt sienna and marine blue, and let them dry.

Remove the masking. Painting the flowers is very simple, since you are not getting really technical with the flowers of the dogwood. You can simply do a light glaze of cobalt blue over part of the whites and be finished with the tree.

If you're painting a white dogwood floret, leave the florets white except for shadowed areas, which you can create with a watered-down cobalt blue. (Also see dogwood branches on p. 86.)

Bare Winter Trees With a #3 pencil, lightly draw a tree with bare branches. With a #4 round brush, paint a wash of burnt sienna, immediately applying a wash of ultramarine blue on the dark side of the tree. Blend the colors with your brush toward the light area. This will cause the colors to mix and granulate, giving the needed texture for the bark.

Leaves If you'd prefer to show the technical differences among tree types, here are examples of oak and maple leaves.

Apple tree.

Dogwood tree.

Bare deciduous tree in winter.

Oak (left) and maple (right) leaves have distinctive shapes.

CONIFEROUS TREES

Evergreen trees, like pines, spruces, and many shrubs, are coniferous, which means "cone-bearing." Many evergreens have narrow, needle-like leaves. Yews, which have no cones but form arillate fruit, are usually included in this botanical order of Coniferales.

Examine the basic shape of the tree you're painting. If it is a cone shape, start filling in the shape by moving in and out of the shape with your brush to make it look like a particular type of tree. You can also use a sea sponge to apply the paint.

Coniferous trees, like all trees, vary in shades of green. Mix the paint to make a shade of green appropriate for the tree you choose. Try mixing various yellows and blues to create just the right green. However, to make a more realistic green, you can add a little red to the mixture. My favorite shades of green are derived by mixing burnt sienna and marine blue. Burnt sienna, which contains all three primary colors, including red, is conveniently mixed for us in a tube. When I need a certain shade of green, I experiment with different yellows and blues with a dab of red added to produce a green more pleasing to the eye.

Pine tree.

Pine Trees With the flat edge of the ½-inch flat brush (or 1-inch flat for a larger tree), held in a vertical position, make a vertical line for the tree trunk. Start at the top and push the brush horizontally to form the branches. I used a mixture of marine blue and burnt sienna for this tree. These two colors produce a great green.

PALM TREES

Draw the trunk of the palm tree. Then paint it with a wash of burnt sienna. With a tissue, lightly lift off the lightest areas. I sometimes use a special brush, called a grass comb, for palm-tree leaves. As the name suggests, this brush also works well for creating grass, texture on wood, and many more great effects.

With a #4 liner round brush, use a mixture of burnt sienna and marine blue to paint the veins of the palms. Now load the grass comb with the same mixture, wiping off the excess paint on a tissue. Begin to make the palm fronds. Start at the bottom and make a large comma type of stroke. Work your way up each branch, making the strokes smaller as you get to the top.

Palm tree.

Although similar techniques can be used to paint a variety of trees, all trees have somewhat different textures and colors. Look around you when you are not painting, and observe the characteristics of different trees. The knowledge that you gather from day-to-day observations can be used later to create realistic colors and textures for any tree you want to paint.

Painting Flowering Bushes

Bushes in a painting can draw the attention of the viewer to a focal point or guide the eye to an area of interest. Although the color and shapes of bushes in real life can vary widely, you will notice that the techniques an artist uses to create a variety of flowering bushes, shrubs, and vines are surprisingly similar. Potted plants draw on many of the same techniques.

A 10-minute potted plant.

Azalea Bushes Draw the branches of the bush, making sure they are randomly placed. Paint the branches lightly with a mixture of cadmium yellow light and marine blue. After the branches are completely dry, you can add the flowers. A mixture of rose madder and opera makes a beautiful combination for pink azaleas. With your #6 round brush held perpendicular to the paper, dab on the color in a random fashion.

Lilac Bushes A lilac bush is painted in a similar way that you would an azalea bush, with a few exceptions. Lilac flowers have more of a cone shape, but the overall shape of a lilac bush is the same as that of an azalea bush.

Azalea bush.

Draw the branches of the lilac bush and paint them lightly with a mixture of burnt sienna and cobalt blue. With your masking fluid, make dots in cone-shaped clusters. Remember that the cones are not perfectly shaped; they have random florets coming off them. Let the masking dry.

Begin painting with a dry-brush technique over the masking with a mixture of marine blue and burnt sienna, which will make a dark blue-green. Paint in the leaves just as you did with the first tree. Let this dry and then remove the masking. With a mixture of ultramarine blue and opera, mixed to make a pretty violet, start filling in the white areas, leaving a little of the white showing for light.

Lilac bush.

Bittersweet branches.

Bittersweet Vines With a #4 round brush, paint in the branches, using a mixture of burnt sienna and ultramarine blue. Allow the paint to dry. Begin applying masking fluid in small dots in and around the branches. After the masking is dry, use ultramarine blue to paint a background wash over both the branches and the masking. Dry the painting. Remove the masking. Use a mixture of burnt sienna and vermilion to paint in a portion of the dots. Paint the outer edge of the florets with cadmium yellow light.

Painting Flowers

Painting flowers can be very rewarding. They can add color and light to a painting, or they can be the painting's focal point. When practicing these few examples, think about all the different flowers you can paint, using the same simple techniques. Also see "Still-Lifes with Flowers" on pp. 125–129.

Flowers also have individual shapes and colors and need to be painted differently, according to the distance from which they are being viewed.

Violas.

Violas Draw the stems of the flowers. Mask out the florets with a dab of masking for each floret. Allow to dry.

Paint a wet-on-wet wash over everything, using cadmium yellow light, and then drop in cobalt blue hue. Allow this to mix on the paper. Let dry.

Remove masking and start painting the florets with mineral violet and cobalt blue hue. Leave some of the whites for contrast. Paint in the stem with a pale yellow-green created by mixing aureolin yellow and cobalt blue hue.

Hydrangeas Lightly draw the shapes of the flowers. Hydrangeas may appear round, although the clusters have an amoeba's shape. Apply masking fluid in flower shapes, four petals for each flower in the cluster. Dry. Paint the shape of the cluster with a dark green, created by mixing burnt sienna and indigo blue. Paint in a few leaves with the same mixture, lifting out light areas with a tissue or a dry brush. Dry and remove the masking. Apply glazes of cobalt blue, rose madder, or light yellow-green—whatever pleases your eye. Hydrangeas change color throughout their growing season, depending on the soil content and acidity, ending in a golden hue.

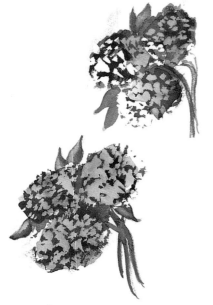

Hydrangeas come in multiple colors.

Daisies and Black-Eyed Susans Draw the outline of the petals and then fill in the edges, creating shadows behind each petal. Paint an ellipse or circle for the flower's center or disk, depending on the angle of view, and draw each petal to a point in the whorl radiating from the disk. Be sure to leave a little space between some petals to distinguish each ray. Now you can begin detail work on the petals.

I find double loading my ½-inch flat brush is the easiest method for doing this. Load one side of the brush with a warm yellow, such as cadmium yellow light, and the other side with a cool yellow, such as aureolin. This will make one side of the petal cool and the other side warm. It also will create the centerline and contrast within the petal.

Daisy.

The disk of the daisy has a texture almost like little dots of orange and red on top of a yellow background. After you finish the center of the flower, you can begin adding shadows.

The black-eyed Susan is similar, but has yellow petals and a dark center. Note the difference in the leaves.

Black-eyed Susan.

Tulips Begin by drawing the outside shape of the tulips and leaves of the plant, then pencil in the shapes of the individual petals.

For pink tulips, beginning with scarlet lake, paint a wash over the tulip petals. Then darken the scarlet lake with a light green created from its complement mixture of ultramarine blue and cadmium yellow light. Now begin detailing the tulip, putting shadows in the crevices behind the petals. Allow to dry.

Add a small amount of cadmium yellow light to the brighter parts of the tulips to create a lighter orange, giving the tulips variation and depth. Let this dry. Continue to do detailing, if needed, blending the colors to give shape to the tulips.

When painting the stems, use the same light green mixture of ultramarine light and use the resulting color to highlight the stems and create a rounded appearance. This will create light and dark areas in the stems that will draw viewers into the painting with the push-pull effect.

Tulips.

Use a mixture of marine blue and burnt sienna to create a darker green to use on the shaded parts of the leaves. For the lighter areas, illuminated in this painting by the sun, use a mixture of ultramarine light and cadmium yellow light. This will add contrast. Fill in a little detail, such as shadows and light areas on the flowers, and you are finished.

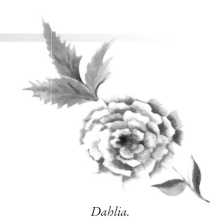

Dahlia.

Simple lilac with leaf.

Clay pot.

Dahlias Dahlias are dense with petals, so the easiest way to paint these flowers is to begin by penciling in the center floret shape. Work your way to the outside of the drawing by adding shapes of the florets under the previously sketched florets until your flower is the size you choose. With a mixture of vermilion and rose madder, begin painting the center floret, leaving the edges white. Continue working your way out to the edge of the flower, and then darken the center of the flower by adding some cobalt blue to the mixture.

Lilacs On a half-sheet of Fabriano Rosapina 140# hot-pressed paper, squirt water randomly from a spray bottle in the area of the painting where you intend to place your lilacs. (See Water Spray, Paint Spatter, and Salt Technique on p. 85.) Then with a brush loaded with Yarka violet paint, splatter paint onto the damp areas and allow it to separate. I suggest doing this on a flat surface so that the paint will not roll down the paper in streaks.

Where you have sprayed water, the paint will separate and begin to create florets and a basic background. Then sprinkle table salt on each of these florets. This will pick up some excess water and pull out the whites of the florets. Allow it to dry.

You can begin adding more color to the florets—cobalt blue, opera, and more violets. Keep in mind that you want to preserve some whites for lights.

Next begin adding some greens for leaves and browns for stems. Paint around the florets to bring their shapes forward. In other words, paint negative shapes that will read as leaves and stems. You can also begin to add positive shapes around the outside of the florets with leaves and branches sometimes in clusters. When painting lilacs, I try not to get too technical by enhancing each shape. I want the painting to be my interpretation of what a vase of lilacs could say to the viewer. I want to remind them of the fragrance and the beauty of spring, simply creating a calm, serene feeling.

You can use a number of techniques to paint realistic lilacs. For this second technique (Sponging Technique shown on p. 85), I use 140# Arches paper. Wet the paper with water as you would when painting the shape of the lilac. While the paper is still wet, charge the water with a brush loaded with cobalt violet. Allow it to dry. With a sea sponge, dip the sponge into a mixture of cobalt violet and ultramarine blue. Squeeze the sponge in your hand to control where the paint will be dabbed. Begin dabbing the paint in the shape of the lilac. Add a stem and you're finished. If you're doing a number of lilacs for the same painting, do them individually for the first two steps.

To finish the lilacs, I added white paint very sparingly in random spots with a sponge for more contrast and light.

Finally, you'll want to paint the vase to give the lilacs a place to live. Remember, when painting glass, all colors surrounding it will be reflected in its surface. So use all those colors when painting the dark areas that give the vase dimension. Also, stems descending into the vase will appear to bend slightly at the waterline, and they'll be slightly distorted below the waterline.

Water Spray, Paint Spatter, and Salt Technique

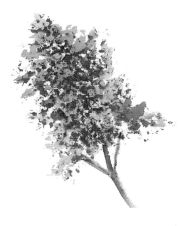

Spray water onto paper, splatter Yarka violet paint onto the damp areas, and allow it to separate into florets.

Sprinkle table salt on the florets to help define them and to pick up excess water and pull out the whites. Allow it to dry.

Begin to add more colors, like cobalt blue, opera, and more violets. But preserve whites. Add stems.

Sponging Technique

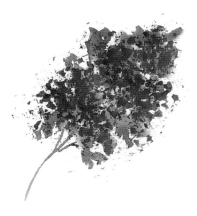

Dip a sponge in paint and apply it to your paper.

Begin to add more colors and white paint, sparingly with a sponge.

Add stems and inner branches. Create dense or airy florets to suit your style.

Dogwood Branches Painting a dogwood tree or just a branch from the tree will make a wonderful still-life subject. Begin by drawing the flower shapes and then mask them out. Then you can put in your background. Allow this to dry before you take your masking off the florets. After you remove the masking, begin painting the florets one petal at a time. If you are doing a pink dogwood, you need to use a cool red such as rose madder, watered down to a very light value. Add shadows to the florets with a mixture of rose madder and a drop of hooker's green or a green made from cobalt blue and aureolin yellow. Add the dark center of the flower and you are finished.

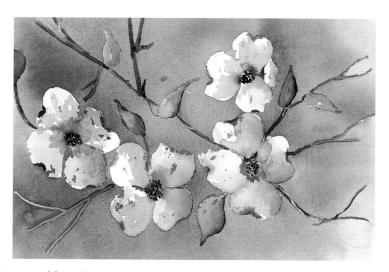

Dogwood branch with white blossoms makes a good subject for a still-life.

Imaginary wildflowers.

Wildflowers Painting wildflowers can be one of the most creative and enjoyable artistic endeavors you can undertake because their numbers and variety allow you to recreate them from your imagination. Splatters of color in flowerlike designs can appear realistic even if no such flower has ever existed. The examples here may not grow anywhere in the world. They're the stuff of imagination. Experiment and allow yourself to turn over a new leaf or find a fresh petal.

Still-Lifes Flowers and plants can become the subject of still-lifes or incorporated into larger paintings. Dewdrops can add a little realism to the leaves or petals. See pp. 125–129 for a discussion of still-life techiques as well as details for creating more flowers (such as pansies or lilies of the valley), see-through glass vases, delicate backgrounds, and more.

Painting Water Droplets

Sketch a rose and draw a small oval shape on a petal where you want the water droplet. You can either mask out this area or paint around it, whatever you feel more comfortable with.

For the flower petals, I used, appropriately enough, rose madder in various tints, tones, and shades. Begin by painting a tint of rose madder (rose madder and water) around the oval shape. Allow this to dry.

At this point remove the masking, if you have chosen the masking technique. Paint a tone (rose madder plus its complement) over the entire section. This will gray down the red.

Mix a shade (rose madder plus violet) and paint around the lighted side of the oval. This dark shading will give the droplet dimension.

Finally, use a razor blade to scratch out a light spot in the center of the droplet. This will allow you to see through the droplet to the paper, giving it the transparent appearance of water.

Water droplets on petals or leaves.

With a little background color, added leaves and stems, and perhaps a dewdrop for realism, even individual flowers like the Dogwood Blossom *(left) or* Phyllis's Rose *(right) can become the subject of paintings of their own.*

The Ropemaker
Marcia Moses, 11 × 14 inches

ADDING FIGURES TO PAINTINGS

PLACING FIGURES in your paintings can add dimension and interest to your work.

To begin drawing a figure, your first consideration should be what gesture the figure will convey to the reader. Is the figure looking up, down, back, or forward? Is he bending, standing straight, slumping over, or kneeling? What is the figure doing?

Begin the figure with the head. Make a small oval stroke. Bear in mind that a head is not as large as people tend to make it. As a general rule, make it half the size you initially think it should be. You can always go back and enlarge the head if need be.

Next add the torso. The torso is like an enclosed "V," except very few people have that small a waist. So cut the bottom pointed edge off.

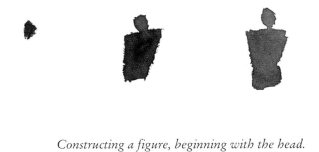

Constructing a figure, beginning with the head.

Add the buttocks, which are essentially a rectangle. Now you are half-finished because the top portion of the figure, from the head to the buttocks, is half of a figure in proportion, with the bottom of the buttocks being the middle point.

The legs make up the bottom half of the figure. Paint in the legs and add feet. Your first reaction here often is to paint the legs too short. Within reason, legs can never be too long. If you are going to err, err on the long side.

Give the figure arms. The arms hit about mid-thigh, if the arms are hanging straight down. So, you must compensate for any rise of the arm, as in, for example, hands placed on the hips, arms crossed over the chest, or a finger pointing.

You can now put a hat on the figure, place a golf club or fishing pole in his hands, or attire the figure in whatever manner called for by the painting.

WALKING. TAKING A STROLL. PLAYING GOLF. LOOKING THROUGH A TELESCOPE. LOOKING DOWN. LOOKING UP.

MORE FIGURES IN ACTION

Have fun playing around with all the different gestures you can paint with this very simple process for making figures. The possibilities are as endless as the activities we engage in every day, whether it's skiing, playing baseball, enjoying the beach, lassoing a would-be bronco, lining up in a queue, sitting, searching for a contact lens, or just standing around.

Creating active figures can be great fun. You don't need to master the complicated features of precise anatomy.

MONOCHROMATIC FIGURES

There can be something ethereal about painting figures with one color. Using just one color in a number of different values can create a peaceful effect in viewers. Some painters, like Picasso, have often painted monochromatically.

As artists we have been trained to think of monochromatic painting as painting with one color. You can, however, mix up to three colors and end up with one color with many values. In this figure of the golfer (shown at right), I used a mixture of vermilion with a little cobalt blue to darken the vermilion a little and to give the color a longer value range.

Monochromatic action figure playing golf.

Figures add interest to your painting. This fisherman blends in chameleonlike with his environment.

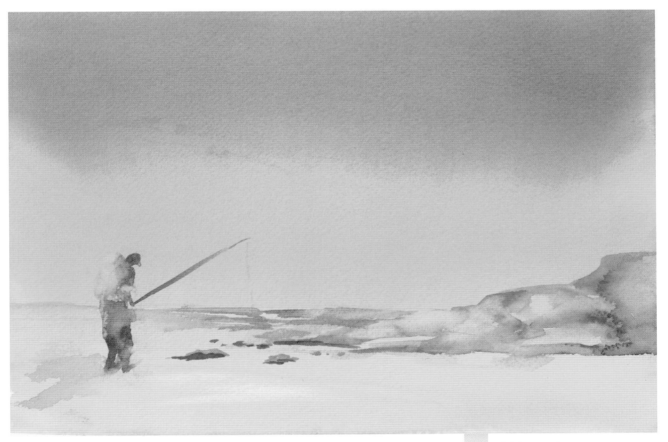

Fishing at Sunset
Marcia Moses, 11 × 14 inches

USING FIGURES TO CREATE A MOOD

Here are a few examples of how we can re-create an emotional moment in a painting by calling upon ideas and feelings we had at a special moment. While on Monhegan Island, Maine, with a group of students, my emotions got the best of me when I saw Cindy serenely sitting and painting on a rock by the ocean. I always find joy in watching students paint, and this emotion stirred me to paint her. It was a simple painting, one that brings forth fond memories.

This reward is afforded an artist who puts figures into a painting. Figures can add emotion to a setting that's interesting in its own right. Figures can make the difference between a painting that's pleasing and one that's memorable.

Karey, my godchild, is now twenty-two years old. For her college graduation, I painted from a photo of her taken years ago at the beach. I always loved the photo and am so happy I painted it. Every time I see the painting I've called Karey, *I enjoy my best memories of Karey as a child. Her sweet, innocent appearance as she looked out at the water from the fishing pier just gives me pleasure.*

Karey
Marcia Moses, 8 × 10 inches

Student Painting
Marcia Moses, 11 × 14 inches

Sharing a Sunset
Marcia Moses, 15 × 22 inches

A couple of years ago, I asked two dear friends to pose for a photo in my living room and act as if they were looking at the ocean. I had an idea for a painting about a couple sharing a moment at sunset and thought this indoor recreation could help cut down immensely on travel costs. Call it artistic license.

I began painting and somehow put it away half-finished. I pulled it out a couple months ago, and I had a better understanding of what I wanted to convey in the painting. I think we are all romantics to a certain degree, and this painting gives me a feeling of peace just looking at the two lovers staring at a sun setting on the horizon. No one needs to know that this horizon was the top of my sofa.

Positive Approaches
to Watercolor

"My task is to make you hear, feel, and see.
That and no more, and that is everything."

—JOSEPH CONRAD

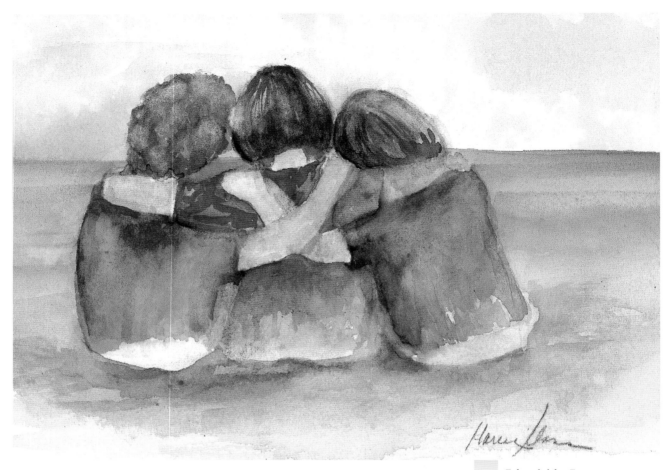

Friendship Forever
Marcia Moses, 8 × 10 inches

PAINTING WITH FEELING

We all have feelings, and feelings are neither right nor wrong. They just are.

Drawing upon these feelings is the essence of painting. You may feel happy, sad, excited, or gloomy as you are painting. Your goal as an artist should be to put those feelings on paper in such a way that you can make your viewer feel them and respond to them in much the same way as you, the painter, felt them when you applied the paint.

This, of course, is a difficult task. I can remember looking out my window and seeing the sunset over the lake near my house. I almost cried with excitement. Well, trying to get others to see the same sunset with the same excitement as I did is nearly impossible.

Nevertheless, with appropriate use of the design elements of color and line, we can do many things to evoke emotions in viewers of our work. Here are some examples.

Color and Mood

Colors can be used to create the mood in a scene to express your feelings. Below are several examples of how you may convey moods and feelings through color. Start observing nature and see how many more you can come up with.

To create a painting that expresses a happy mood, use mostly bright warm colors, such as red, yellow, and orange. To make a picture that expresses a sad mood, use dark colors. Blues and grays are particularly effective, but if you add a complement to any color, it will gray it down and give the painting a more sad or gloomy mood. Graying down a painting is useful for painting a rainy-day scene, for example.

To show a cold winter's day, use cold colors, such as blues and whites. To paint an underwater scene, use cool colors such as blue, green, and purple. To show an angry mood in your artwork, use shades of red. Red is an intense color that reminds us of angry feelings as well as other passions.

"Do what you can with what you have, where you are."

—THEODORE ROOSEVELT

Line and Emotion

Line in a design does much the same thing as color. The lines of your drawing or painting are laid out on a page in such a way as to create specific feelings in the viewer. Here are ways lines can be used to evoke emotions.

Horizontal Lines Horizontal lines suggest a feeling of peacefulness or calm. Objects parallel to the earth are at rest in relation to gravity. Therefore, compositions in which horizontal lines dominate tend to be serene.

Vertical Lines Vertical lines communicate a stately or majestic feeling. Erect lines seem to extend upward beyond human reach, toward the sky. They often dominate in an architectural manner. Extended perpendicular lines suggest an overpowering feeling.

Horizontal lines.

Vertical lines.

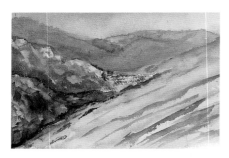

Diagonal lines.

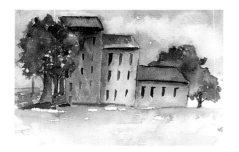

Horizontal and vertical lines in combination.

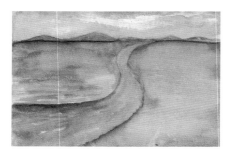

Curved lines.

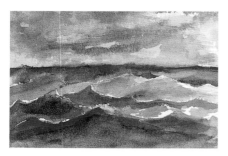

Zigzag lines.

Diagonal Lines Diagonal lines suggest a feeling of movement or direction. Since objects in a diagonal position are unstable in relation to gravity, being neither vertical nor horizontal, they are either about to fall or they are already in motion. In a two-dimensional composition, diagonal lines are also used to indicate depth, an illusion of perspective that pulls viewers into the picture, creating a sense of space in which one could move about. Diagonal lines are useful in creating a feeling of movement or speed.

Horizontal and Vertical Lines in Combination A combination of horizontal and vertical lines communicates stability and creates a solid foundation. Rectilinear forms stay put in relation to gravity and they're not likely to tip over. This stability suggests permanence, reliability, and safety. The horizontal and vertical lines used together in buildings, for example, imply stability in the painting far beyond the structures themselves.

Curved Lines Soft shallow curves suggest comfort, safety, and relaxation. They recall the curves of the human body and therefore have a pleasing, sensual quality.

Zigzag Lines Zigzag lines suggest confusion, turbulence, even frenzy. The violence of waves in a storm evokes confusion, turmoil, and even anger. The directions they suggest are this way and that, not fixed, not formal, never staid.

Remember, the quality of the line is in itself a fundamental visual language in a way that cannot be claimed by any other single element. Its use is so universal that we are all profoundly sensitive to it. Even without an artist's training, we can extract considerable meaning from the kind of line used in a drawing.

The quality of the line in itself contributes to the mood of the work, and for the master artist, line quality is a fundamental expression of his or her style.

Ways of Seeing

We all see things differently, and this is a good thing. If we all saw everything the same way, we would live in a very dull world. If we all had the same feelings all the time, it would be a boring world.

That's why I wrote this part of the book, so that you as an artist wouldn't expect everyone to get as excited as you do about what you're feeling as you paint. If they don't, you may believe your feelings are not validated. So feel what you want; paint what you want. Whether or not this gets the attention of anyone else is irrelevant. It's what you felt at the time that makes your painting valuable.

Sometimes being an artist is not easy. We tend to want to please viewers or cater to people who love what happens to be popular at the time. I once painted lighthouses for a living. I was not happy with what I was doing, but my lighthouse watercolors were in demand and paid my bills.

Don't get me wrong. I love lighthouses and I tried to learn everything I could about every lighthouse in the United States and also abroad. I studied my subject from bottom to top and in and out, because this was my interest at that time. I still love lighthouses and always will, but many other things and places stir feelings in me that I never knew possible. Now I paint in the moment, capturing whatever feeling it is inside me that causes so much emotion that I could cry.

The entire time I was finishing a painting of my father, I shed more tears than could be held back by the Hoover Dam. This is what painting with feeling is all about. Examine your feelings when they come upon you, and you will not lack a subject.

The pine in the foreground, curved walk, moonlit snowflakes, rising smoke, deep snow, icicles hanging from house and lighthouse roofs, and the luminous colors that read as white help create a homey Christmas feeling.

"Even in front of nature one must compose." —EDGAR DEGAS

Peace on Earth
Marcia Moses, 8½ × 11 inches

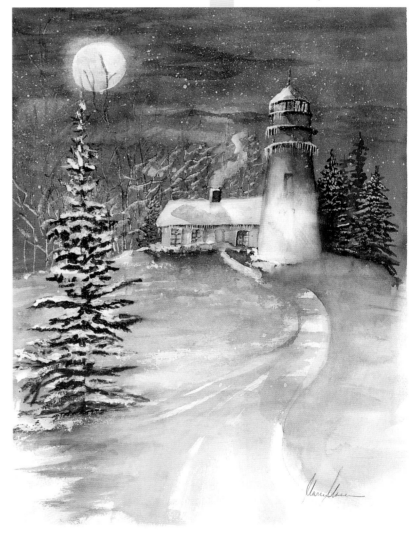

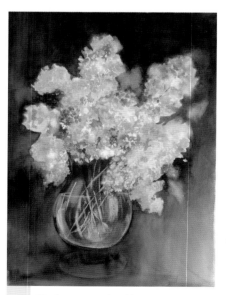

Hydrangeas in Glass (early stage)
Marcia Moses, 22 × 30 inches

Solving Problems

In life, we are always solving problems, and in art it is no different. As artists, part of our job is solving problems. We need to ask ourselves basic questions about how to rectify the artistic situations we find ourselves in and to debate our options.

Is the painting still in the design phase? Have I put in a center of interest? Is the composition pleasing to my eye? Am I having painter's block? Is the color right? Do I have enough contrast?

These are some of the more important questions I ask myself, and sometimes the answers lie within the questions themselves. The solution may be as simple as applying a glaze to either the entire painting or just parts of it. Then again, the answer may be to take more drastic action, such as starting over or scrubbing down the painting with Ivory soap and a sponge and rescuing what is salvageable.

I recall a student in one of my classes being really frustrated with what she was doing, and the more frustrated she got, the thicker she applied the paint to the paper. It was becoming muddy and no longer resembled a transparent watercolor painting. In essence, she was applying the paint as an artist would apply oils.

I told her she had two options. She could put it away and think about it. Or she could scrub it down and start all over. She chose the latter and ended up with a gorgeous piece after repainting. She learned a tough lesson that she will likely never forget. Today she never applies watercolors like oils. She has a gentler touch. While there are moments to apply watercolor in a more opaque fashion, less is usually more.

It's best to plan your composition before you begin painting. That way, you'll have fewer if any problems to solve when applying paint to paper.

As I worked out my thoughts about how to salvage my composition *Hydrangeas in Glass,* I began by applying a really dark green wash with a mixture of marine blue and burnt sienna. After painting around all the flowers and vase, I had a lot of hard edges that were not going to work in the painting. I applied about three more glazes of the same mixture and was beginning to be pleased with the results, although I still needed to do something about the edges.

As I began to soften the edges, all of a sudden the painting came to life. My decision helped me solve the problems I had encountered.

Hydrangeas in Glass
(finished painting)
Marcia Moses, 22 × 30 inches

CONTROLLING DOMINANCE

When we begin a painting, our first thoughts always should be directed toward planning a good composition. Having too many dominating images in a painting will cause confusion. The desired relationship of elements to be used can be accomplished by first doing a sketch of your subject, which will allow you to rearrange the composition in a pleasing manner.

In the painting *Celebration*, the ice bucket is the dominant part of the painting. The fruit basket and the silvery glass are less dominant, but they help lead the viewer's eye to the key player in the painting, the ice bucket, holding what we assume is champagne.

Let's see how dominance can affect the finished painting. In the first example (bottom left on this page), there's a dominant object in the foreground. This object, however, appears to lead the viewer back to the supporting tree in the background, which is the real focus of interest, not the tree in the foreground.

In the second example (bottom right on this page), the eye doesn't know what to look at first because neither tree is dominant. From a design standpoint, the two trees are stagnant. One negates the other. The eyes of the viewer cannot decide what to look at.

Think of a painting as a play. You have the star of the show, and the rest of the cast supports that main character. If all the actors tried to be the star, it would be a very confusing play, and the main character would get lost in the shuffle. The same is true in a painting.

Celebration
Marcia Moses, 15 × 22 inches

One tree dominates.

The two trees share or fight for dominance.

This is why we have all the tools of composition: to allow us to tell a good story with our work while drawing attention to the object we consider the star.

A painting can be dominated by color, line, shape, or any of the elements of design to achieve what you want the painting to say. Use objects of lesser importance to create unity throughout the painting by placing them so that they have a pleasing relationship to each other. Use the supporting cast to lead the viewer's eye to the star of the show.

TAKING A BREAK FROM A PAINTING

After working a few weeks on the painting *Flower Box,* I decided to set it aside. Sometimes we can be so involved in a work that it becomes frustrating and we lose perspective on what we're trying to achieve.

Flower Box
Marcia Moses
22 × 30 inches

I waited a couple of weeks and when I came back to it, I knew right away what the painting needed. There was not enough contrast at my hot spot, or center of interest.

I decided to add a glaze of cadmium yellow light to brighten the ivy. With a large amount of water, this color was diluted enough to make it more transparent and to allow the colors I was painting over to shine through. Because the painting was rather large (a half sheet, or 22 × 30 inches), I applied the glaze with a 1-inch flat brush. This brush could apply the color with broad strokes, which would allow me to cover more area with each stroke.

I began the glaze in the bottom left corner of the painting and worked my way up diagonally to the area of the flower box. That was my center of interest. It's the brightest area of the painting, and I wanted to make it even brighter so that it would stand out.

With deliberate strokes, I kept moving up the diagonal to the ivy. After allowing this to dry, I decided to add another glaze, using rose madder, cadmium yellow, and a small amount of cobalt blue to produce a sienna color. I glazed the window and rocky wall, especially the part of the wall below the window, to create contrast with the window.

Finally, I glazed the ivy again with heavily diluted cadmium yellow. The painting finally came alive to me. I had captured what I had intended when I started the painting—the feeling of warmth from flowers sitting in a window. The painting became very inviting to me. So, I signed it and called it finished.

FINISHING A PAINTING

"How do I know when I am finished with a painting?"

To determine the answer to this question, review the list of design elements and principles (pp. 22–26). These rules provide the basics for the whole painting process. In the painting *Beach Umbrellas*, for instance, I wanted to make a statement about the peace and tranquility in a beach setting with waves rolling in, the warmth of the sun beating down on my face, the feeling of sand on my feet, and the warm wind blowing in my face. This is what painting with emotion is all about. As artists, we see and feel things differently in life, and being able to express those feelings and emotions on paper is a gift.

When I had put all the emotions I felt on that piece of paper, I knew it was a finished project.

You can only know in your heart if a painting is finished. While design rules help ensure a pleasing composition, in art, rules are made to be broken. You can determine if you've placed your center of interest in the correct spot in the painting by checking your design and making sure all the colors work together. Critics may argue that a painting was not composed according to the rules, but only you can decide what pleases you at that moment. Only you as an artist can feel in your heart that you've successfully captured the desired moment in that particular painting.

The curved lines and soft colors suggest serenity, while the angles and direction the umbrellas and grasses "point," remind us that it's a windy day.

> *"When a painting problem crops up, don't rush to fix it....Invite the muses to bring you a new solution."* — CAROLE KATCHEN

Beach Umbrellas
Marcia Moses, 15 × 22 inches

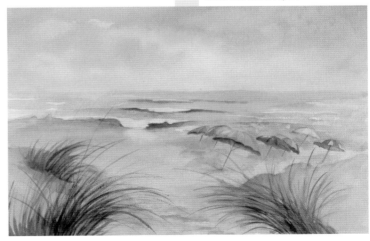

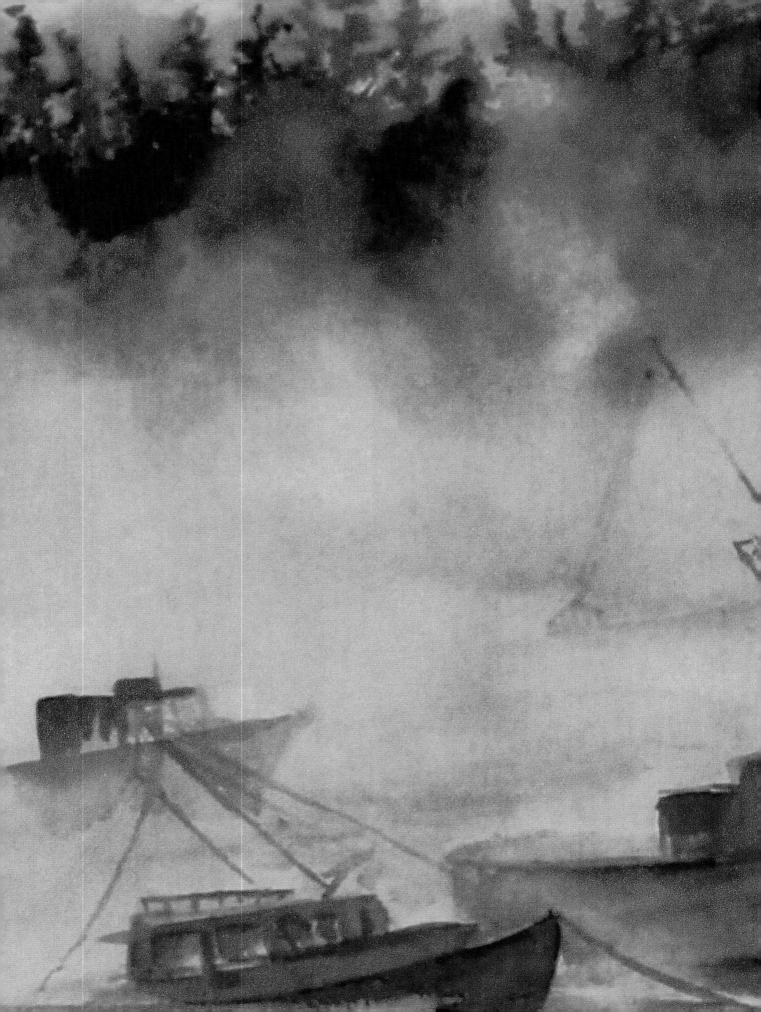

Putting It All Together

"Don't judge each day by the harvest you reap but by the seeds you plant."
—ROBERT LOUIS STEVENSON

Winter Trees at Sunrise
Marcia Moses, 11 × 14 inches

MOODY SKIES

"Let us be grateful to the people who make us happy; they are the gardeners who make our souls blossom."

—MARCEL PROUST

BUILDING A CERTAIN MOOD is integral to the painting process. This process begins in the design phase, when the artist decides what he or she is trying to convey.

Skies, for instance, can convey excitement when painted bright and sunny, peacefulness if painted in restful sunset colors, dreariness if done in grays, or uneasiness if in dark and threatening colors that suggest stormy weather. Vincent Van Gogh created a radiant mood with a star-filled sky in his painting *The Starry Night* (1889). Though a little bizarre, this moody painting, probably one of his best, illustrates his childlike sense of awe. There are many ways to express what you feel at any particular moment, but the trick is putting these feelings down on paper.

In my painting *Fishing at Sunset* (see p. 91), I wanted to create a solitary fisherman caught up with his thoughts in the peacefulness of a sunset.

When painting *Beach Grass*, on the other hand, I hoped to capture the turbulent mood of the moments before a storm by portraying the sky in dark blues and making the beach grasses appear to blow in a strong wind.

Fog clouding a landscape suggests mystery. Creating a foggy scene draws on the same techniques for creating skies.

Beach Grass
Marcia Moses, 15 × 22 inches

Painting a Foggy Scene

I love the early morning by the sea and wanted to capture that feeling in *Fog in the Morning*. The work was in essence a re-creation of the early morning fog that I had so often seen in the harbor at Gloucester, Massachusetts. There was something so peaceful about the morning I painted this, yet it also seemed a little eerie. I've wondered how these boats find their way in such a dense fog. Actually, the boats happened to be moored, so I could paint them without a photo reference.

I painted in all the boats and trees, then the water. I then wet the paper around the boats and trees and started dropping in a diluted burnt sienna and a little rose madder here and there. I proceeded to drop in a little aureolin yellow for a cool, damp feeling. I let these colors mix on the paper and then dry. Using a damp sponge, I began lifting off areas to show the light and depict the fog. After adding a few final details, I had captured my version of the Northeast Atlantic coast in *Fog in the Morning*.

Fog in the Morning
Marcia Moses, 15 × 22 inches

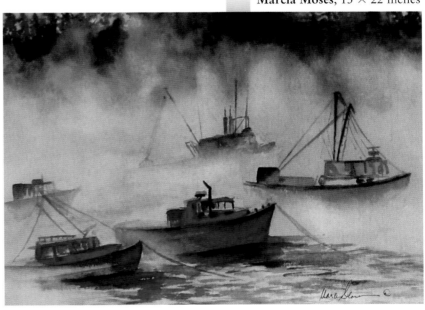

Painting Clouds

Clouds are classified by how high up in the atmosphere they form. The long, stringlike clouds found in rows at low altitudes are stratus clouds. Rows of small, cottony clouds found at similar altitudes are called stratocumulus. Large, billowing cottony clouds are cumulus clouds. These can extend up to great altitudes. When the top flattens out into an anvil shape, it is called a cumulonimbus cloud. The term *nimbus* usually describes a dark, rain-bearing cloud. Cumulonimbus clouds are the ones that generate dramatic thunderstorms and hail. The wispy clouds found at very high altitudes are cirrus clouds.

Clouds can function like a Rorschach test or inspire all sorts of fancies. Hamlet teases Polonius about a cloud that looks perhaps like a camel, a weasel, or a whale.

Rain-Filled Clouds For rain-filled clouds, drag a damp sponge vertically on the paper to pull the paint down to look like rain. Even with rain, the final image can be gloomy or bright, depending on the chosen colors.

Rain clouds.

Stratus Clouds To paint stratus clouds, make long, horizontal brushstrokes across the paper with a flat, wide brush. Lines of the clouds need to be almost parallel, but paint them freehand without a ruler. If they're perfectly parallel, they'll look artificial. Remember that perspective applies to clouds, too. They become smaller, narrower, and paler the farther away they are. You could use a light or dark blue, such as cerulean or ultramarine, for sky around stratus clouds, and use ochre and a mixture of ultramarine blue and burnt sienna for the dark, rain-filled bits of the clouds.

Cumulus Clouds Cumulus clouds are puffy, cottony clouds that signal fair weather. They can seem stationary, but often cumulus clouds drift across the sky at relatively high speeds. Imagine the strong winds stirring up cumulus clouds and try to translate this action into brushstrokes that trail off at the lower edges of the clouds. Work fast and meticulously, resisting the temptation to make these clouds simply white with dark shadows. Clouds reflect colors, and they may include reds, pinks, purples, yellows, and grays. Concentrate on the shadows that give the clouds shape. For cumulus clouds try these colors: opera for pink tints, yellow ochre and raw sienna for hints of gold, and burnt sienna mixed with blue for the deepest shadows.

Cirrus Clouds Cirrus clouds are feathery and float very high up in the atmosphere, usually forming in high winds. Be light-handed so that you can capture their wispiness. If they're pure white, consider lifting off the blue of your sky to reveal the white of your paper. You can do this with a damp brush or a tissue.

Stratus clouds.

Cumulus clouds.

Cirrus clouds.

Monhegan Island
Marcia Moses, 11 × 20 inches

Painting Water

Nothing is more beautiful than an ocean rolling in, banking itself on the shore with waves in various colors of blue, green, white, or whatever colors are reflected from the sky and surrounding objects.

When a fishing boat returns with its catch at sunset, the reflections from the sky almost make the boat glow. A lake surrounded by trees and wildflowers reflects all those colors in its water. Reflections of docks or pilings on water are wavy when that water ripples, but they become almost perfect images of themselves in calm water.

Painting water can be very exciting and rewarding. Here are a few tips.

Ocean Spray
Marcia Moses, 5 × 7 inches

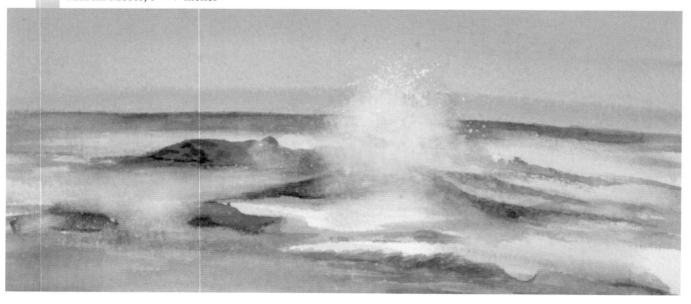

Looking at Reflections Try to capture what you can with a camera so that you have something to refer to when you get back to the studio. As we know, the continuous change in light also will cause the reflections to change drastically. So if you are not a fast painter, and cannot capture the scene outdoors, you will be able to do so in your studio.

Masking If you mask out the crest of a wave, that's an effective way to preserve the white of a whitecap. You can then paint over the masking and add the spray of a wave striking a rock or other objects by spattering a small amount of white paint or sprinkling salt on damp paint.

Sparkle For sparkle or other highlights on water, you can use a single-edged razor blade and scrape with the side of it. This will lift only the paint that has not gone down into the wells of the paper. Do this on completely dry paint. As you might expect, this is a good technique to use on rough paper, which has deep wells.

Sky Colors Remember, water usually reflects the colors of the sky. Therefore, plan your color scheme accordingly.

"The work of art must seize upon you, wrap you up in itself, and carry you away. It is the means by which the artist conveys his passion. It is the current which he puts forth which sweeps you along in his passion."

—AUGUSTE RENOIR

REFLECTIONS IN WATER

In still water, reflections appear as almost a mirror image. Usually they are not an exact mirror image, however, but rather mirrorlike, with distortions caused by ripples in the water's surface.

For example, imagine a sailboat in calm water. From the dock you see the side of the boat meeting the water, the windows and top of the cabin, the mast supporting the sail, and perhaps a portion of the boat's deck. In the reflection, you see the side of the boat, some of the windows, and the mast. You don't see the top of the cabin roof or any of the deck in that reflection.

Do a test of your own. Set a coffee cup on a mirror and observe the reflection from different points of view. You see and know what's inside the cup, but the inside of the cup is not in the reflection. Observe other objects.

See how the boat and land are reflected in still water.

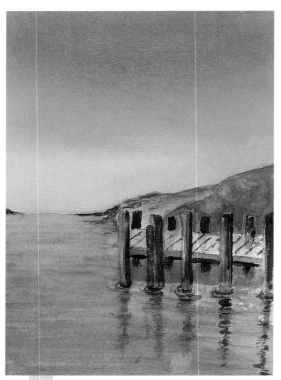

Approaching the Dock
Marcia Moses, 8 × 10 inches

In moving water, remember that the reflections break up horizontally. Also, they appear longer than the objects they reflect if the light source is closer to the horizon, and shorter if the light source is more directly overhead.

An object that leans away from you will appear to have a shorter reflection than itself. An object in or near water, leaning toward you, will have the opposite effect. The reflection will appear longer than the object being reflected. Reflections of dark objects usually appear slightly lighter in value. Reflections of light objects appear slightly darker in value. This is because the reflections of the objects take on the color of the water.

The painting *Approaching the Dock* illustrates the rules of reflection for nearby and distant objects. The colors of the sky at sunset are mirrored in the surface of the water. Those bright orange and yellow hues also make the blue of the water considerably brighter than it would be when reflecting a dark sky.

Contrasting with those bright colors are the darker reflections of the shadowed underside of the dock and the unlit sides of the pilings. Notice that even in relatively calm late-day water, the reflection of the pilings is still distorted by the gentle motion of the water. And the reflection of the pilings at the surface of the water is circular because of the movement of the water around them.

> *"We ascribe beauty to that which is simple; which has no superfluous parts; which exactly answers its end; which stands related to all things; which is the mean of many extremes."*
>
> —RALPH WALDO EMERSON

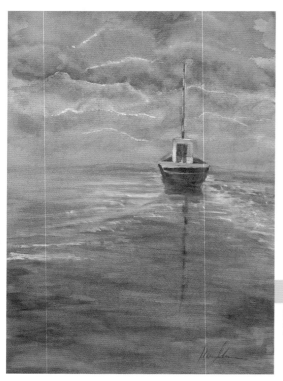

Mariner's Sky
Marcia Moses, 15 × 22 inches

BOATS THAT FLOAT

In a composition with an object floating in the water, you'll need to show reflections of the object in the water. If the water is still, those reflections will emulate more closely the lines of the image than if the water is rough. Rough water will distort the reflection so that it appears wavy. The object's colors will be more muted in a rough-water reflection, if not nonexistent.

In the painting *Sailing Away,* the water was calm on the small lake where I found my subject. The relative smoothness of the surface is ideal for illustrating the rules of reflections.

This boat happens to be getting sunlight from its opposite side, so its reflection is cast on the side of the water you can see beneath the boat at the bottom of the painting. The darkest values of the reflection are just at the bottom edge of the boat, where it is touching the water. The values become lighter as they move away from the boat. This is what makes the boat seem as though it is floating.

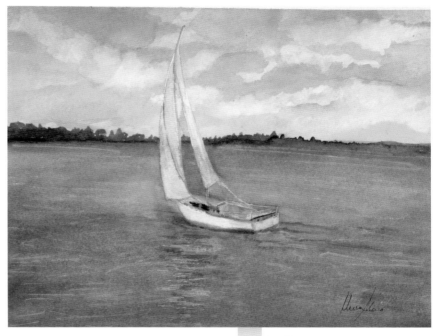

Ted's Boat
Marcia Moses, 11 × 14 inches

It is important to consider that any refection will contain colors of both the object being reflected and the color of the water. These colors can be mixed either on your palette or on the paper. If the water is still, I find it more effective to mix the hues on the paper. But if the water is rough, sometimes an effective mix can be achieved on the palette, then applied to paper, with the lights and darks of waves pulled off or painted on.

The water also will reflect secondary objects in a painting, such as clouds and trees in the background. Those reflections, however, will be minimal because of their distance from the viewer's eye.

Note that when it is cast on even the most calm of water, no reflection is an exact, mirror image of an object. The movement of the boat or of the air coming in contact with the water's surface causes enough rolling motion in the water that, at the very least, the edges of the reflection will be distorted.

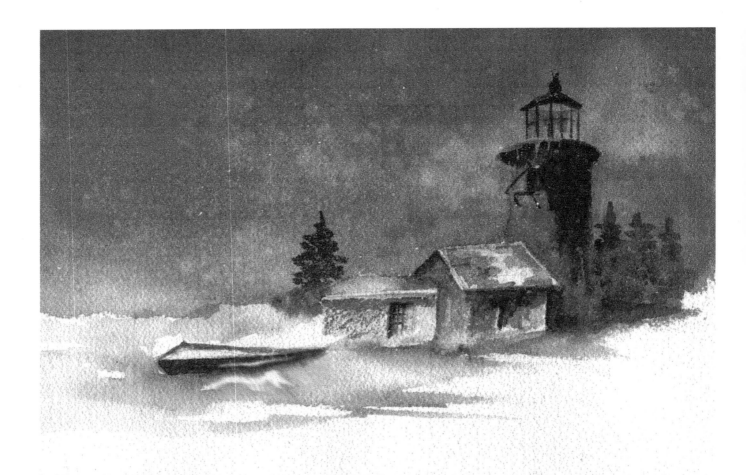

After the Snow
Marcia Moses
11 × 14 inches

Painting Snow

Obviously, snow can stir up many emotions. It creates excitement for anyone who ever made a snowman as a child. It brings to skiers' minds the recollections of afternoons spent on their favorite slopes. And it can resurrect the fond memories of gatherings of relatives on holidays past. Sometimes viewing a painting with snow in it is as pleasurable as looking out the window at real snow, watching flakes of it gently accumulate on the ground like a pristine white carpet.

Of course, snow can also create negative emotions, like a sense of gloom when you know you have to drive in it, shovel it, or be housebound because of it. But frankly, people rarely think of those moods when they view an artistic snow scene. They just remember the good times. We all love snow…when it appears in a painting and not on our driveways. Being from the Midwest, I have perhaps a better mental image of snow than artists from warmer parts of the country. But even if you live in a warm climate, you can take delight in snow.

I paint snow from my memories of it, and I get warm fuzzies from re-creating it on paper. This is one of the best parts of being an artist. You can capture the moment in your art, even if it is a moment preserved only as a memory from your past.

SNOW SCENE WITH SUNLIGHT

Paint a wash of vermilion on the top two-thirds of your paper, and then, while the paint is still wet, go over it with cadmium yellow light. With a pencil, draw in tree lines and the outline of mountains over the wet paint. This will cause the paint to seep into the paper and create dark shades of those two colors.

While the paint is still wet, use a mixture of vermilion, cadmium yellow light, and a little ultramarine blue to paint over the tree lines as if you were making pine trees in the background. This will give the painting some depth.

Make the tops of the mountains white by dragging a tissue over the top edge of the mountains. Use that same mixture that you used on the tree shapes to enhance the bases of the mountain, which also creates depth.

Now move down to the bottom third of the paper, which still will be stark white. Put in some shadows in the snow—dark areas that have been created by color reflected from the mountains, trees, and sky in the background. Use a small amount of vermilion with a lot of water. Then use your dark mixture to enhance those shadows.

Sunlit Snow
Marcia Moses, 8 × 10 inches

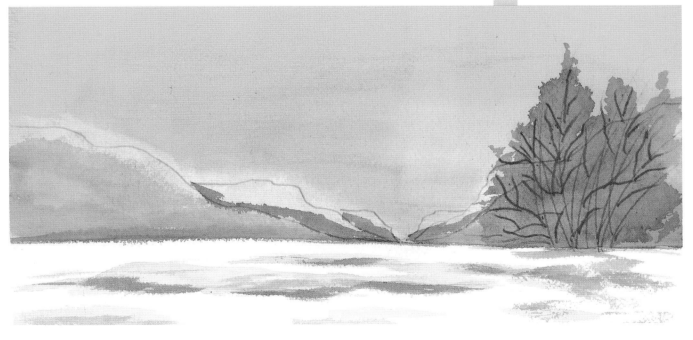

SNOWFLAKES

Sprinkling table salt onto a slightly damp surface is an effective way of creating snowflakes in a painting. Salt soaks up paint, leaving a little star around each bit of salt.

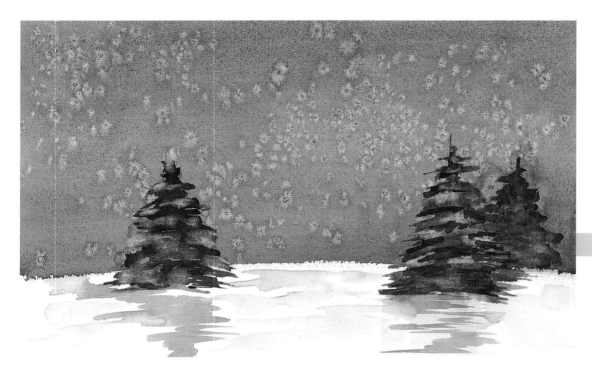

Winter Night
Marcia Moses
8 × 10 inches

"You must look within for value, but must look beyond for perspective."

—DENIS WAITLEY

First apply the wash to the scene where you wish to have snowflakes. But have your salt handy, because the timing of its application is critical.

Paint with the paper flat. Watch it drying and just before it loses its shine, sprinkle on the salt. Leave the painting flat to dry thoroughly.

When the paint dries completely, brush off the salt with your hand or with a clean tissue or paper towel. As I said, timing is important when you apply the salt. If the wash is too wet, the salt will absorb too much paint and melt, creating snowflakes that are too big. If the wash is too dry, the salt won't absorb enough paint and you won't get any snowflakes.

Don't use too much salt; that could ruin the delicacy of this effect. Don't try to arrange the grains of salt. Snowflakes should be random. You can, however, alter the way the paint reacts to the salt. To create a blizzard, for example, tip the painting a little so that the paint and salt slide to one side.

MORE SALTY HINTS

Salt can be used in the same way to create a starry sky on a dark wash or to give texture to a variety of objects. Crushed or ground salt sometimes gives better results than table salt in these instances because it's coarser. Sea salt is crushed salt. It can be used to create the spray of an ocean wave, the texture of a covered walk, or the uneven surface of rocks.

This salting technique doesn't work very well on paint that has dried and been rewetted. It's not going to bring life to the paint to reveal the white of the paper because the paint already has set in.

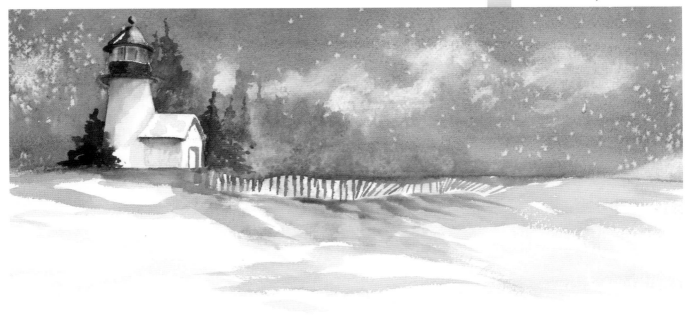

Snow Fence
Marcia Moses, 12 × 22 inches

Covered Bridge
Marcia Moses, 11 × 14 inches

Create a balanced cityscape.

Cityscapes

Constructing any painting requires a lot of time, thought, and problem solving. This is true of the simplest of landscapes, but it is even more difficult to paint buildings and other structures in perspective. When designing a cityscape, you will also need to take into consideration the feelings the architecture of the buildings will convey to viewers.

While searching for a cityscape to illustrate this point, I was in awe of a little street in Annapolis, Maryland. The street had the right feel for what I had in mind. It looked like an Old World scene. I liked how colorful its row houses and storefronts appeared. It seemed cozy.

I began planning *Annapolis Street Scene* by completing a sketch in one-point perspective. In other words, all lines of the buildings beside the street extended to one point on the horizon line. As I finished the drawing, I began to feel that the hardest part of this painting—its design—was over. Then came the fun part—the painting.

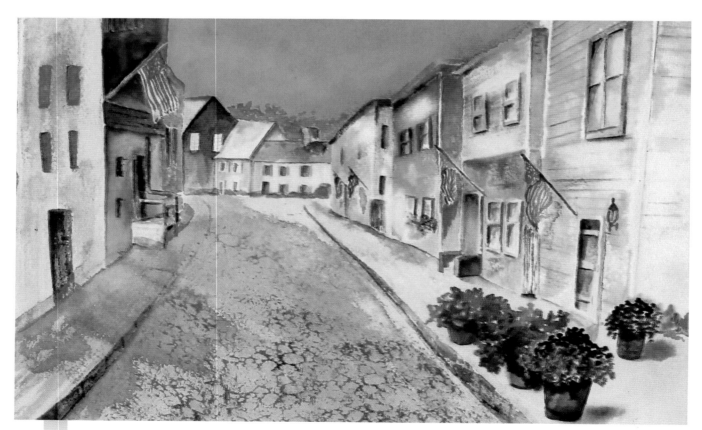

Annapolis Street Scene (first stage)
Marcia Moses, 15 × 22 inches

One side of the street was illuminated by the sun and the other side was blocking the sun, casting shadows. I began with washes of different colors on each of the individual houses, immediately giving the painting a glow. Then I moved around the painting, finishing detail work on the building with calligraphic strokes under the roofs and on the shadowed sides of the buildings. I painted in the flags with curved strokes, making the flags appear to be hanging in folds. It gave them movement. I then painted in the sky with a cobalt blue so that it wouldn't draw attention away from the houses.

I added a cobblestone texture to the street by rolling a round sponge across its surface, and gave dimension to the curbs by painting the street side of them darker than their tops. I added a few potted plants on the sidewalk at the lower right corner to create a point from which to lead the viewer's eye into the painting. The last thing I did was paint muted trees in the background, behind the houses at the end of the street. I did so to add contrast to the sky, and thus draw attention away from it, toward the row houses, which were my focus of interest from the start.

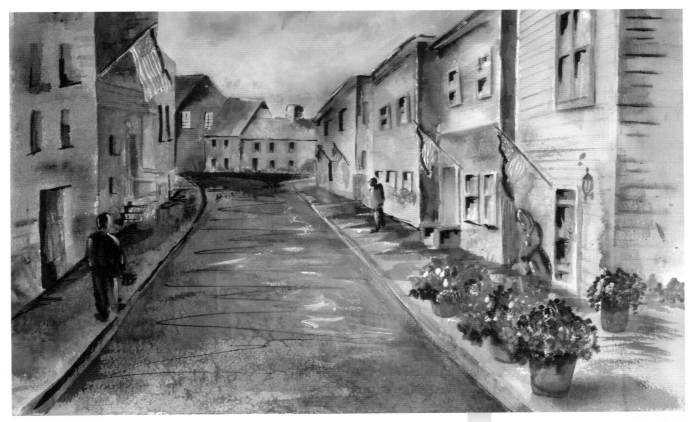

Annapolis Street Scene (finished)
Marcia Moses, 15 × 22 inches

Window Treatments

Many painters have used windows in their paintings to tell the story they want the viewer to see.

In many of Andrew Wyeth most impressive paintings, he brings light in through a window in such a believable manner that you can almost feel the warmth. He uses it to create shadows of colors that make the scene come alive. The light from the window establishes a mood so enjoyable to dwell in that it pulls viewers into the painting.

To begin your own painting of a window, observe not only the window itself, but also the placement of objects near it that will reflect the light coming through it. After you get your composition the way you want, decide which direction you want the light to hit the objects inside the window. Also, determine what your focal point will be. Make sure it is in one of your hot spots. (See the grid with hot spots on p. 26.)

Mask out your lights or paint around them, whichever is easiest for you. I began my own painting of a window by giving texture to its casing, leaving light areas where the sunlight would strike the window-sill, and adding dark areas where the framework holding the window-panes would cast shadows. I darkened the underside of the framework to add dimension. The top portions of the framework should be painted a light value, if the light through the window is coming from the top. If the light is coming from the bottom, say, for example, if the house sits on the top of a hill and the sun is

Light Through the Window
Marcia Moses, 22 × 30 inches

setting, the light values should be added at the bottom of the framework. Also decide if the space inside the window will be lighted from artificial light or only by the light coming through the window.

In my painting *Light Through the Window,* I made the room dark, and the only light coming from the sun. The light is reflected on all the objects. When painting, carefully decide how to get the feeling that everything in some way is touched by the light.

Notice that the floor was drawn in one-point perspective, as was the window. By putting these in perspective, the painting gains dimension and depth, and this in turn unifies the painting.

I finished the work by painting the brooms on the back wall, pulling the light values that define them out of the dark color of the wall on which they hang. This not only added more objects of interest to the painting, but created contrast in a large area of otherwise dull color.

Interestingly enough, *Light Through the Window* was not my first attempt to capture this particular setting. Weeks before, I had painted *Window Light,* which included a vase of bittersweet instead of the butter churn. A bowl of eggs and a pot of blueberries sat in front of the window on a table, instead of on the floor.

I decided that I had too much information in the painting. *Light Through the Window* was a simplified version painted on a larger piece of paper. I included fewer items, placing them on a floor instead of on a table. I added a trio of brooms to the wall behind the window, to pull the eye back into the painting. And I lengthened the shadows created by the window, as if to signal a sunset. It was the same setting, but it became a different painting, one that in my view was more interesting than the first. After all, the brighter apples seemed ready to be eaten.

"Creativity is allowing yourself to make mistakes. Art is knowing which ones to keep."

—SCOTT ADAMS

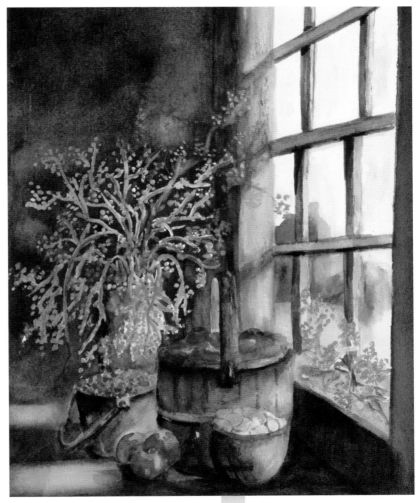

Window Light
Marcia Moses, 11 × 14 inches

LIGHT SOURCE

In the painting *Lantern, Flowers, and Light*, the light source is coming in the window at mid-afternoon and illuminating the lantern from the right side. The light is slightly touching the flowers, creating a warm feeling. The soft warm edges of the sunlit side of the lantern give the lantern a glow that lets the viewer know where the light source comes from. The cool hard and soft edges on the left side of the lantern allow the viewer to see the reflected light and to give the lantern the appearance of a cylinder. The lights and darks, and hard and soft edges, move the eye around the painting.

POTTING SHED

In the painting *Potting Shed*, I used the light source near the open door to reflect the beauty of the old Windsor chair, just sitting there waiting for its owner to relax and enjoy the flowers outside and inside. I applied numerous glazes on the background walls to make them lighter to show the sunlight. After moving a damp sponge across the paper to remove the paint to create the sunlight, the whole painting became sunlit and warm.

Lantern, Flowers, and Light
Marcia Moses, 11 × 14 inches

Potting Shed
Marcia Moses, 11 × 14 inches

Still Lifes

Still Lifes with Pots, Jars, and Cans

An interesting thing about watercolor is the way an artist can create different moods while portraying similar subjects. This is accomplished by employing a variety of techniques available to the watercolorist.

In the painting *Still Life*, for example, I treated the cans almost as unfinished objects, using just enough lines to indicate to the viewer the form of the cans. Then I softened and lost enough edges to simplify the composition. I gave the background texture to compensate in the design for that missing detail. This allows the viewer to fill in the detail with his own imagination.

This technique contrasts with the one I used in the more structured *Books, Jars, and Fruit*. In this painting, I softened just enough of the edges to make the make the jars appear round and realistic. I maintained almost all the outlines of each object and kept the background simple and without much texture so that the form and color of those objects would be emphasized.

Where *Still Life* is impressionistic, *Books, Jars, and Fruit* is realistic. Two quite similar subjects have produced two very different paintings.

Interestingly, a combination of both techniques can be employed in a single painting to achieve an entirely different mood.

While the pale background of this painting helps give the objects dimension, it also suggests a less serious mood than that in the darker, more obscure still life shown above.

Still Life
Marcia Moses, 15 × 22 inches

Books, Jars, and Fruit
Marcia Moses, 15 × 22 inches

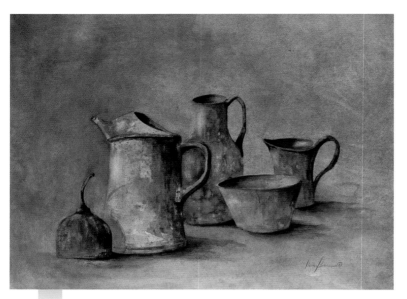

Antique Shop
Marcia Moses, 22 × 30 inches

In *Antique Shop*, I made the background more textured, but kept much of the detail of the cans. I was able to separate those objects from the background, without their details appearing too busy, with the lights and darks that gave the cans their form.

I painted cans in an almost identical manner in *From the Attic*, but I reversed the value scheme. In *Antique Shop*, the darks of the cans help bring them forward against a light textured background. In *From the Attic*, the lights of the cans help set them off by contrasting them with a dark background that has minimal texture.

From the Attic
Marcia Moses, 22 × 30 inches

Still Lifes with Flowers

I love most flowers, but certain favorites really excite me. Review the section on how to paint individual flowers (see pp. 82–86).

Painting flowers gives me a special feeling, an emotional high. I can almost smell their fragrance as I paint them. (If they're in my studio, I can indeed smell them.) When the first lilacs and lilies of the valley make their debut in my garden, I am moved by the emotion created by their wonderful fragrances. I must paint them.

This is not surprising. As painters we are emotionally tuned into nature and all the beauty that's around us, so the natural inclination is to paint what we feel.

"Beauty is in the heart of the beholder." —AL BERNSTEIN

LILACS

In the painting *Basket of Lilacs*, I began with a contour drawing. I drew around the edges of the composition and later filled in the shapes. I concentrated on the basket first. I decided to have my light source coming from the left side of my paper. After drawing the shape of the basket, I started filling in the weave of it with my pencil.

Next, I painted a wash of aureolin yellow over the entire basket. I proceeded to apply a wash of rose madder and then cobalt blue on the shadowed side, which gave me a basic dark color.

After allowing the paint to dry, I began to apply the lines of the weave, to make the basket come alive. I used a mixture of burnt sienna and a little cobalt blue. When you paint these lines, make a line and then clean your brush, leaving a little water on the brush. Immediately push the line up into the crevices of the basket. This is a blending action that creates a line that is not so definite as to be unrealistic. You may want to come back later and repeat the same technique to make the line stronger, especially on the shadowed side of the basket.

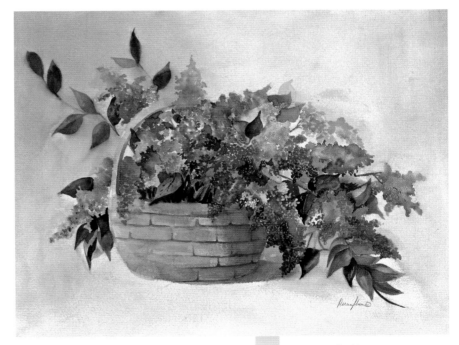

Basket of Lilacs
Marcia Moses, 22 × 30 inches

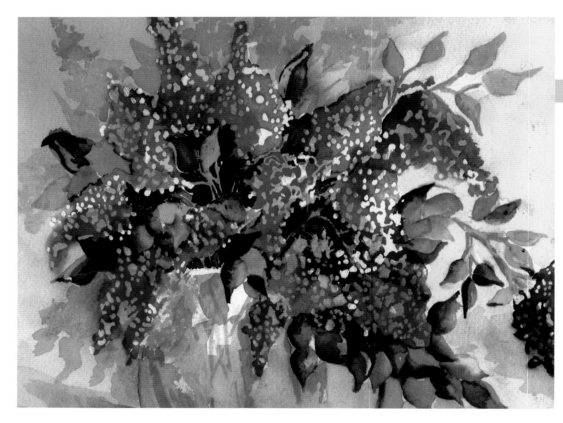

Abigail's Wedding
Marcia Moses
11 × 14 inches

"The artist must have something to say, for mastery over form is not his goal but rather the adapting of form to its inner meaning."

—Wassily Kandinsky

Move on to the flowers and start filling in the shapes of the flowers with droplets of water (see p. 87). Then add color to the water droplets and let the watercolor do the work, spreading as it wants to spread, within the outline of the water. As long as you have left some of the white of the paper, you will have the contrast you need to create the darks and lights of a flower petal.

Using the same mixture of cobalt and burnt sienna, add a few branches and more lines to the basket. Paint in a few shadows and a background of marine blue and burnt sienna, applied wet into wet, with salt thrown onto its surface to create texture. These are the color combinations I used. Experiment with other color mixtures in your own painting.

In the painting *Abigail's Wedding,* I used a masking fluid to preserve the whites in the lilacs. My niece was getting married and loves lilacs also, so this was a perfect opportunity to paint her a gift. Note that I also added more detail, such as shadows and color, in the background of this painting. It helps lead the eye into the painting, and it also helps mute the appearance of lilacs that were painted in a darker hue. There also are a lot more hard edges in this painting, where I used masking. I chose to keep them there when I removed the masking, to create contrast.

PANSIES

When beginning the painting *Pansies,* I concentrated on the background, making it a light yellow, complementary to the violet, so that the bloom itself would be more clearly defined.

In the second step, I concerned myself with the actual flowers. Here I added various hues of green, a blue-gray mixture, and violet. It helps to isolate the actual subject matter—to make the background merely a pattern rather than actual foliage. This is a good trick if you find your eye wandering around the painting. Defining the background will cause you to focus on your subject.

At this stage, I added some vermilion and violet to the background to brighten it a bit, choosing complementary colors to heighten the colors in the flowers. This technique is not difficult to grasp, but the only way to fully understand the way colors will work together is to experiment using colors that are complementary (opposite each other on the color wheel). Complementary colors enhance each other. They bring out the best of each other and add to the brilliance of the painting.

To the pansies themselves, I added ultramarine blue and rose madder, allowing them to mix on the blooms. I used vermilion to gradually build up the definition of the lower blooms.

Notice that I had drawn in more blooms and leaves in the original sketch. I deleted some of that detail during the painting process to simplify the design and highlighted the flowers that remained.

I layered color on those remaining blooms. Watercolor is a medium where the subtle use of color in blended washes will cause the colors to flow together and appear more realistic. Each time you add a layer, it heightens the color, defines your subject, or creates interesting patterns within the painting.

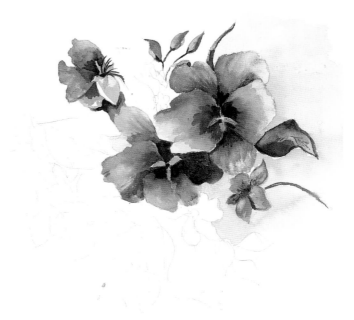

My original pencil sketch for the painting Pansies *included more blooms.*

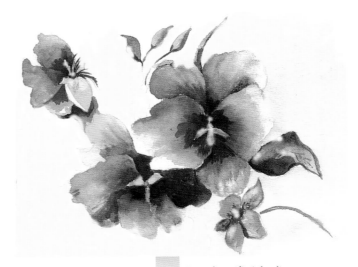

Pansies (finished)
Marcia Moses, 11 × 14 inches

HYDRANGEAS

Hydrangeas are fun and interesting to paint. The colors vary from one plant to another, so you sometimes think they are chameleons, always changing their colors. The light was perfect when I took this photo as reference material. These hydrangeas were cut from my garden and dried in this vase for a future painting. It is from this photo that a painting came to be.

Notice that the shape of hydrangea blossoms also varies and how the variegated hues of green in the flower flow from the vase on the upper right. This flower was masked out, preserving the whites. Then the background of the flower was painted a deep green for depth.

I removed some of the masking, leaving a few of the florets without color, to keep the whites. Where the mask was removed, I painted a light green, using a mixture of cadmium yellow light and a small dab of cobalt blue hue. I then removed the remaining masking and left those areas white to create contrast. You can soften the color at the edges of those white florets with a

Photo of hydrangeas in a vase.

Painting reflected light in the vase for the hydrangeas.

Preparing hydrangea blossoms with negative painting.

damp brush or sponge. Use the same procedure with all bunches of florets, using different combinations of color.

Notice that there is reflected light in the purple vase. This light gives the glass dimension and shape. If you look at glass in a lighted setting, it will reflect light from various sources: sunlight, the object it is sitting on, the background light, or any other source of light the glass has contact with. The contact could come from a light across the room.

When you look at glass, squint your eyes and see the light and dark shapes. Then paint them as you see them.

The light source in this painting, *Hydrangeas in Glass*, is coming from the right side of the vase, but the reflected light is also on the left in various shapes. The stems were masked out and painted last with a little burnt sienna.

In this portion of the painting, I show the blossoms of the hydrangeas as small, seedlike particles that appear before the actual, full hydrangea blooms. I found these an interesting addition to the painting and gave them different shapes for variety. They are generally pea-shaped, however, and are usually violet or brown. The pea shapes lend believability to the work. I gave them depth by negative painting, adding darker shades around them.

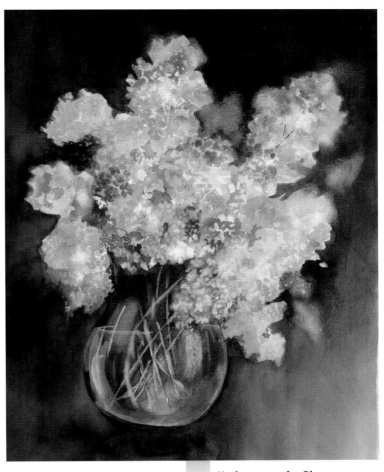

Hydrangeas in Glass
Marcia Moses, 22 × 30 inches

You could also enjoy a study in drawing individual hydrangeas with their leaves (see p. 82 for basics). However, many of the same techniques for painting lilacs, such as sponging, spattering, spritzing, and lifting out whites, can also be applied to painting hydrangeas. (See pp. 84-85.) Both flowers have numerous small florets making up the larger bloom.

Lilac and leaf.

LILIES OF THE VALLEY

There is nothing like seeing that first sprig of a lily of the valley sprout out of the ground. It is a sign of great things to come. Flowers are really a gift to all of us; they fill up our senses of smell, sight, and touch.

I always am reminded of the movie *My Fair Lady,* where Audrey Hepburn played Eliza Doolittle, a flower girl in the late 1800s. She created little bunches of flowers for men to buy for their ladies after an opera or elegant affair. Her goal, after meeting Professor Henry Higgins, was to learn to speak the Queen's English so that she could someday have a flower shop of her own. She wanted to be accepted by the socialites of her time. Eliza wanted them to respect her for the beautiful gifts she created. She was a dreamer and her fairy-tale dreams came true. She went from a lowly flower girl to a princess of sorts, as least in the eyes of her many admirers.

Becoming an artist is somewhat like a fairy tale for me, and I have only begun to fulfill my dream. I feel like Eliza sometimes when I can take a simple, beautiful flower and re-create it on paper. The flower sometimes becomes a princess of a painting.

The painting *Lilies of the Valley* was inspired by the emotions I felt at the moment the florets came to life, sending their fragrance through the air. I felt I had to paint them well enough so that I could almost smell them when I looked at the painting. I keep this painting hung on a wall that I can see whenever I come into my studio in the early morning, and it always

Lilies of the Valley
Marcia Moses, 14 × 18 inches

reminds me of that wonderful fragrance and of the day the flowers emerged. One of the gifts of being an artist is having the ability to preserve such moments, and the emotions that are associated with them.

Lilies of the Valley was surprisingly easy to paint. I began by making small oval-shaped dots travel up the stem with my Masquepen. After allowing these to dry, I painted a wash of aureolin yellow over the entire surface of the paper. While the paint was still wet, I spattered the surface with a low value of marine blue and moved the paper around so that the paints would mix together and create a soft, warm background.

After the background dried completely, I started painting in the leaves of the flowers, the shape of the glass bowl, and the stems inside the bowl. Then I lifted the masking from the florets. I used a wash of aureolin yellow on parts of those florets and left others white. I added a little detailing to the florets with some darker greens, made with a mixture of marine blue and burnt sienna. I also did some negative painting with the same color behind the stems in the top part of the bowl.

SUNFLOWERS

Forms found in nature, like sunflowers, can also assume stylized designs.

Sunflowers
Marcia Moses, 15 × 22 inches

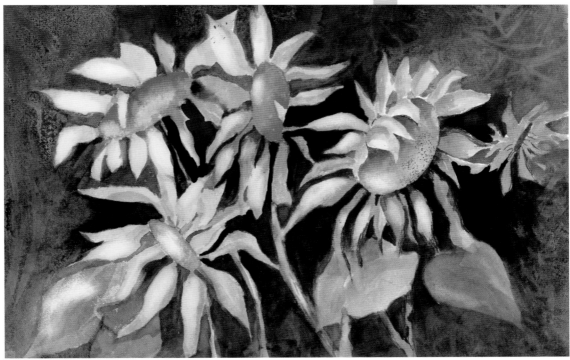

Watercolor Students' Gallery

"Students: Who is the happiest of men? He who values the merits of others and in their pleasure takes joy."
—JOHANN WOLFGANG VON GOETHE

To My Students,

I have been given a great gift through teaching art to students from all over the world. This gallery is merely a small sample of thousands of artworks created in my workshops, seminars, and studio. You, my students, have given me much more than I could have possibly given you. Watching you grow and become the artists you are today gives me great pleasure. Thank you for enriching my life. This Watercolor Students' Gallery is dedicated to all of you.

— Marcia Moses

I Love Color
Haley Moses (age 10)
4 × 8 inches

The artist, who has cerebral palsy, created this painting with her feet.

Foot Dance
Ruthann Brumbaugh, 15 × 22 inches

Penguins
John Fichter
15 × 22 inches

Rhododendrons
Carol Eschliman, 15 × 22 inches

Birdhouse and Flowers
Nancy Deveau
5 × 7 inches

This delightful painting was the artist's very first watercolor.

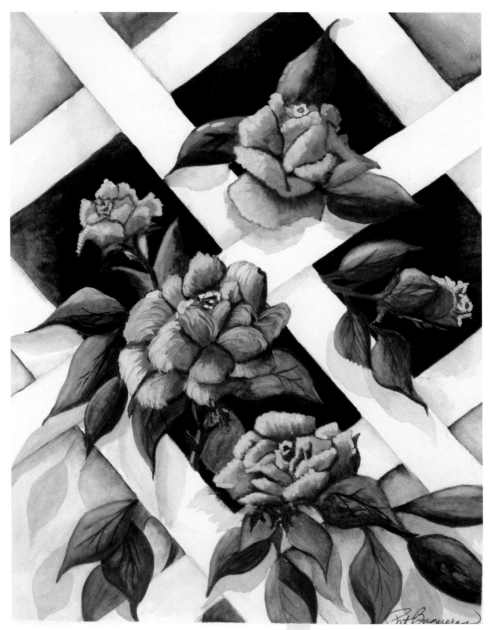

Trellis Roses
Pat Bagueros, 11 × 14 inches

The Bistro
Mary Nieto, 11 × 14 inches

The Collection
Mary Nieto, 11 × 14 inches

Tenement Houses
Gary Brown, 11 × 14 inches

Running on Time from New York to Akron
Joe Wolfe, 15 × 22 inches

Burma Barn
Del Karnuth, 11 × 14 inches

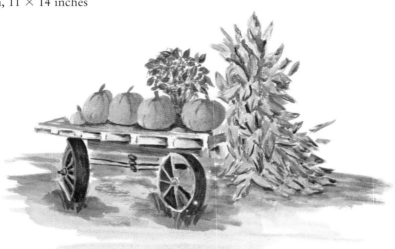

Fall Harvest
Susan Noddin
11 × 14 inches

Bright Morning
Kris Wyler
8 × 11 inches

Le Pear
Phyllis Amato 11 × 14 inches

The Old Barn
Susan Noddin, 11 × 14 inches

Holiday Glow
Carol Eschliman, 11 × 14 inches

Patriotic Porch
Cindy Alber, 11 × 14 inches

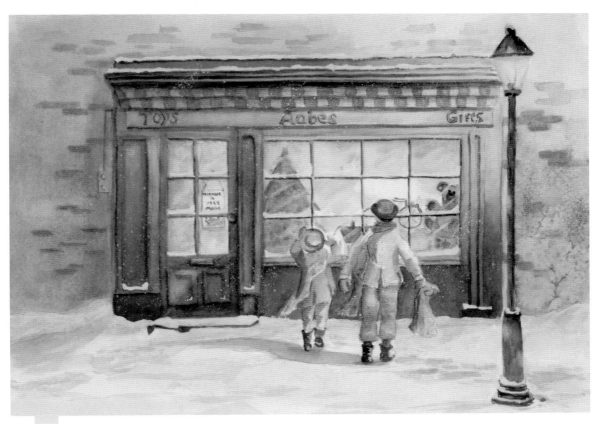

Ed and Me in New York
Lucy Burns, 8 × 10 inches

The Newsboy
Gary Brown, 11 × 14 inches

Bittersweet and Lace
Lucy Burns, 22 × 28 inches

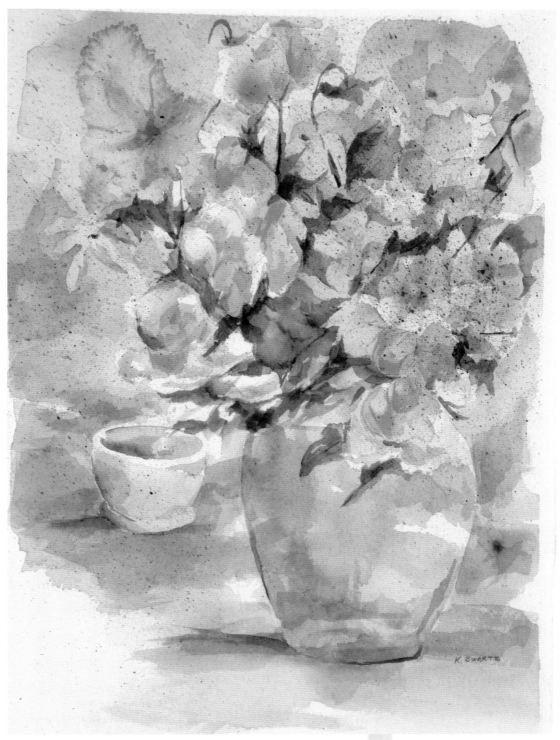

Floral
Kay Swartz, 11 × 14 inches

Snow Skiing
Muriel Bachtel, 4 × 6 inches

Holly Day Sleigh
Giovanna Nicandro, 5 × 7 inches

Priority Delivery
Gary Brown, 11 × 14 inches

Winter Delivery
Shella Marzich, 11 × 14 inches

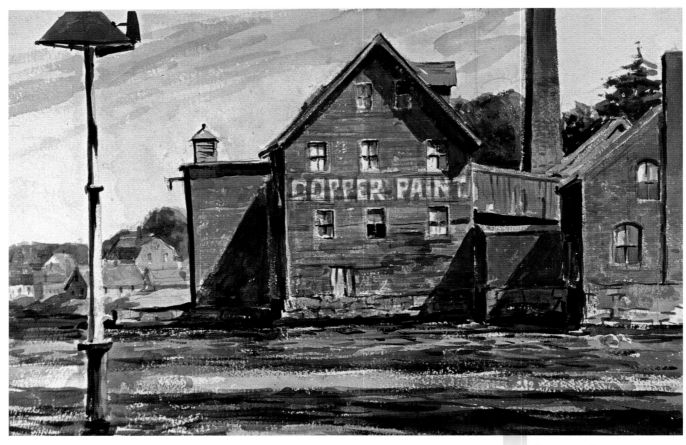

Copper Paint
Jeff Weaver, 15 × 22 inches

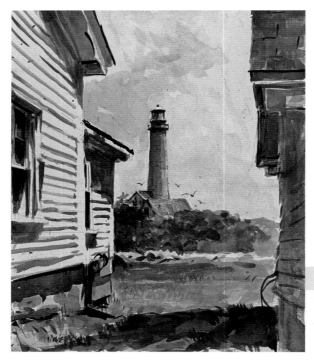

The Keeper's House
Jeff Weaver, 11 × 14 inches

Sea Forms
William A. Moses, 22 × 30 inches

Hot Peppers
John Moses
11 × 14 inches

Green Glass Bottle
Kevin Singerman
11 × 14 inches

Light Breaking Through
William A. Moses, 8 × 10 inches

Morning Rose
Phyllis Amato, 11 × 14 inches

Lilacs
Rebecca Nicola
11 × 14 inches

The Gazebo
Vicki Johnson
11 × 14 inches

Melanie
Patricia Thomas, 11 × 14 inches

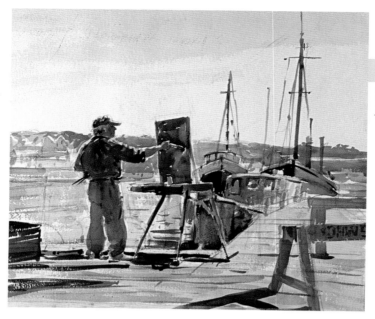

Painting at the Wharf
Jeff Weaver, 11 × 14 inches

Golden Sunrise
Gordon Hewitt, 15 × 22 inches

Gulls
Gordon Hewitt, 15 × 22 inches

At the Beach
Susan Kelley, 5 × 7 inches

Glossary

ALTERNATION Creating a pleasing variety or mix of things in a painting. Contributes, with repetition, to the rhythm of a painting.

ANALOGOUS COLORS Colors near each other or closely related on the color spectrum, especially those with common hues.

ANALOGOUS COLOR SCHEME Composition using closely related colors.

BACKGROUND The dominant colors, either textured or smooth, that provide the setting for the points of interest in a painting.

BALANCE Aesthetically pleasing integration of elements in a painting; the relative weight given objects or areas of a painting. Conflicting elements need to be brought into visual balance. Often asymmetry works best and is most pleasing.

BLENDING (1) Smoothing the edges of two colors so that they have a smooth gradation where they meet. Watercolor washes will dry with hard edges unless you work on dampened paper. (2) Mixing two or more paints.

BRISTLES The hairs on a brush used for painting. Soft and stiff bristles made of sable, Kolinsky sable, hog, goat, ox, squirrel, wolf, synthetic, and combination hairs are available.

BRUSH A watercolor brush consists of a handle, ferrule, and bristles. When buying brushes, be sure that the hairs are firmly attached inside the ferrule and that there are no splayed or loose hairs. The brush should point or edge well and return to its original shape quickly. The belly of the bristles should hold a lot of color and release paint slowly and evenly. Brushes come in a variety of shapes and sizes: round, spotter, rigger, mops, wash, flats, and Asian.

BUTCHER'S TRAY An open palette used for watercolor that doesn't have wells for paint.

CHARGING Applying a first color to paper with a brush and then applying a second color to the wet paint of the previous color.

COLD-PRESSED PAPER This paper variety (CP) is also called NOT, which means it was not made by the hot-pressed process. It has an open or coarse texture. Hot-pressed (HP) paper is smooth and has less texture.

COLOR Produced when light strikes an object and then reflects back into our eyes. Color has three properties: (1) *hue or tint*, the name, e.g., red, yellow, blue, etc.; (2) *intensity, the purity and strength* of a color, e.g., bright red or dull red; and (3) *value*, the lightness or darkness of a color. *Also see pigment.*

COLOR WHEEL A radial diagram of colors in which primary, secondary, and sometimes intermediate colors are displayed as an aid to color identification, choosing, and mixing.

COMPLEMENTARY COLORS Hues directly opposite each another on the color wheel. When placed side by side, complementary colors are intensified; when mixed together, they produce neutral colors or a range of grays. When mixed full strength, they produce dark gray or brown.

COMPLEMENTARY COLOR SCHEME Using two colors opposite each other on the color wheel in your composition, such as red and green.

COMPOSITION The organization, design, or placement of individual elements in a work of art; how the unity, harmony, balance, rhythm, contrast, dominance, and gradation work within a painting. The term *composition* is often used interchangeably with the term *design*. Composition means the total content of an artwork; design means the arrangement of its elements, layout, or plan.

CONFLICT This occurs when seemingly opposing ideas are introduced. While conflict draws interest, if it remains unresolved, we may be dissatisfied with the painting. Resolve conflict by using dominance; emphasize a particular shape, color, or line.

CONTOUR A line that creates a boundary separating an area of space or an object from the space around it.

CONTRAST The play of light against dark, warm against cool, and soft against hard, etc., in elements or figures in a painting.

CONTROLLED DRIP The process of applying paint to an already wet surface, allowing the paint to flow into the water.

COOL COLORS Colors with a blue undertone or blue bias.

CRIMPS The indentations in the metal ferrule that hold the bristles of a brush in place. The more crimps in a ferrule, the better the brush.

DESIGN The planned organization of line, shape, color, texture, direction, value, and space in a work of art. The seven principles of design are unity, harmony, balance, rhythm, contrast, dominance, and gradation. Design also refers to the arrangement of elements, the layout or plan of an artwork.

DIMENSION The state of having shape and depth, achieved through such techniques as shadowing and texture.

DOMINANCE The center of interest or focal point. The principle of visual organization which suggests that certain elements should assume more importance than others in the same composition. With conflicting shapes or ideas, resolve the conflict by emphasizing one or the other; allow it to dominate.

DOUBLE LOADING Putting two distinct colors on opposite sides of a brush and applying them simultaneously.

DRY BRUSH A painting technique in which, as the name suggests, a little bit of paint is put on a dry brush. When applied, it produces a broken, scratchy effect.

DRY ON DRY A watercolor technique of applying paint with a dry brush on dry paper.

DRY ON WET A watercolor technique using a dry brush loaded with paint applied to wet paper.

ELEMENTS OF DESIGN The basic components used by the artist when producing works of art. Those elements are color, value, line, shape, form, texture, and space.

FERRULE The metal cylinder that surrounds and encloses the hairs on a paintbrush.

FOREGROUND The objects in a painting intended to appear closest to the viewer.

FORGIVING Describes paint that can be easily lifted from paper, or smooth paper that allows paint to be easily lifted from it.

FORM The physical appearance of a work of art; its materials, style, and composition.

GLAZING A very thin, transparent paint applied over a previously painted surface that has dried. You'll be able to see the various glazes

beneath the other colors. If you use opaque colors, the results can be muddy. For glazing, you need to use transparent colors.

GRADATED WASH A wash that is light or thin in an area where little color has been applied and gradually becomes darker or heavier in another area, where more color has been applied. This is sometimes also called a graded wash.

GRADATION A gradual, smooth, step-by-step transition or change from dark to light values, large to small shapes, rough to smooth textures, or one color to another.

GRAY SCALE The range of neutral values or shades of gray.

GRID A series of horizontal and vertical lines marked off evenly on paper or on a picture to aid in drawing the picture and to locate centers of interest. *Also see* hot spots and rule of thirds.

HARD EDGES Painting crisp distinct lines on the outer portion of an object.

HARMONY The unity of all the visual elements of a composition achieved by repetition of the same shapes, colors, or other characteristics. Close association of objects or design elements in a picture.

HOT-PRESSED PAPER Hot-pressed (HP) paper is smoother than cold-pressed paper, with less texture, sparkle, and brilliance.

HOT SPOTS Where important objects or images in a painting should be placed. These are areas of more than usual interest, activity, or action in a painting. Divide a rectangle into thirds horizontally and vertically to create nine smaller rectangles. The four points where grid lines intersect one another are called the "eyes" or hot spots, suitable to place the painting's center of interest. *Also see* the rule of thirds.

HUE The color of a pigment or object. A gradation or attribute of color that permits colors to be classed as red, yellow, green, blue, or an intermediate between any contiguous color pair.

INTENSITY The degree of purity or brilliance of a color.

KOLINSKY SABLE Fur of the Siberian sable (a mammal related to the weasel); these hairs are used for the finest sable brushes. Now rare, many brushes not actually made from the Siberian mammal go by this name.

LANDSCAPE A painting of an outdoor scene that may or may not include structures and people. Landscape shape also refers to a composition that is wider than it is tall.

LAYERING Applying additional color to paint that's still wet. Layered colors are usually transparent. Glazing is usually done with wet paint on already dry paint.

LIGHT SOURCE The direction from which objects in a painting are being illuminated.

LINE A mark made by an instrument as it is drawn across a surface.

LOADING THE BRUSH Wetting the brush with water and dipping the bristles into paint.

LOCAL COLOR The actual color of an object being painted, unmodified by light or shadow. (Grass is green.)

LOST AND FOUND EDGES Softening or eliminating the contour of an object in some areas, while leaving distinct lines in other areas.

MASKING FLUID A quick-drying liquid latex gum product used to cover a surface on a painting to protect it from receiving broad washes of paint. Many brands are available. When finished, remove the masking fluid by rubbing it off with a fingertip or an eraser.

MIDDLE GROUND The area of a painting between the foreground and background.

MONOCHROMATIC Having one color or hue; light and dark shades of a single color plus white.

MONOCHROMATIC COLOR SCHEME Using a single color in a composition in a range of values.

NEGATIVE SPACE The space in a painting around the objects depicted.

ONE-POINT PERSPECTIVE When all angle lines converge at a single spot.

OPAQUE Does not allow layers of color beneath it to show through.

PAINTS Watercolor paints consist of finely ground pigments bound with gum-arabic solution which enables the paint to be heavily diluted with water to create thin, transparent washes of color without losing adhesion to the support. Some paints have glycerine or ox gall added; it's best to avoid those for watercolor. Watercolor paints come in two basic types, pan paints and tube paints. Pan paint is pre-poured

in pans or half pans as well as in small, covered palettes. Tube paints or pigments are usually more expensive and of higher quality. They come in sealed tubes from which you can squeeze out a little paint onto your palette.

PAPER WEIGHT The thickness of a sheet of paper, as expressed in pounds, relative to a ream, or 500 sheets. For example, 500 sheets of 140-pound paper weigh 140 pounds.

PERSPECTIVE Representing three-dimensional volumes and space in two dimensions in a manner that imitates depth, height, and width as seen with the eyes.

PIGMENT A coloring substance made from plants, earth, or minerals and other natural or synthetic pigments. Paints with the same color name can vary markedly from brand to brand because of a different formulation or mixture of pigments.

PLEIN AIR Related to painting outdoors.

POSITIVE SPACE The space in a painting occupied by the object depicted (not the spaces in between objects).

PRIMARY COLORS Any hue that, in theory, cannot be created by a mixture of any other hues. Varying combinations of the primary hues can be used to create all the other hues of the spectrum. In pigment the primaries are red, yellow, and blue.

REPETITION Recurring themes in an artwork; repeated sizes, shapes, line directions, and more contribute to a picture's unity.

RHYTHM The variety (say, alternation) and repetition of design elements create rhythm in a work of art.

RULE OF THIRDS A simple method for finding hot spots in a painting or photo. Divide the rectangle of the painting or photo into thirds horizontally and vertically, to make nine smaller rectangles. At the four points where the grid lines intersect one another are the hot points or "eyes" of the painting where one could place the painting's center of interest.

SCRAPING Use the angled end of your brush, a piece of an old credit card, or even a razor blade to scrape paint off the surface of your paper. This needs to be done on a damp, not wet (shiny), wash.

SCUMBLING Moving a brush on paper in a dabbing pattern.

SECONDARY COLORS A hue created by combining two primary colors, such as yellow and blue mixed together to yield green. In pigment, the secondary colors are orange, green, and violet.

SHADE A color that has been mixed with violet, the darkest color on the color wheel, in order to achieve a darker version of that color.

SHAPE A two-dimensional area having identifiable boundaries, created by lines, color, or value changes, or some combination of these.

SOFT EDGES Effect created by painting the contour of an object so that it is indistinct.

SPACE In painting, space may by defined as the distances between shapes on a flat surface and the illusion of three dimensions on a two-dimensional surface.

SPATTERING Loading paint onto a brush, then tapping the brush handle on the handle of another brush or on your wrist, and allowing the paint to spray onto the paper. This helps create texture in a painting; it can also be purely decorative. The dry brush, sponge, and an old toothbrush make useful tools for spattering. Mask with tracing paper those parts of the painting that you don't want to be spattered.

SPONGING Natural or synthetic sponges can create a mottled effect of texture in paint. Control the amount of paint by simply squeezing the sponge slightly where you want a drier application.

SPRITZING Using a spray bottle to apply water or paint.

STILL LIFE A painting subject of small inanimate objects, such as fruit or jars.

TECHNIQUE Any method of working with materials to create an art object.

TERTIARY COLORS Six colors positioned between the primary and secondary colors on the color wheel.

TEXTURE The surface or tactile quality of an object—smoothness, roughness, softness—and trying to re-create this appearance in paint.

TINT A color to which white has been added. For example, white added to green makes a lighter green tint. In watercolor, in order to make a lighter green tint, you add water.

TONE A color to which its complement was added to gray it down.

TRANSLUCENT Allowing light and other paint colors to pass through and be seen.

TRANSPARENT Allowing light to pass through so that objects can be clearly seen on the other side.

TRIAD COLOR SCHEME Using three colors that are compatible, in various values, in your composition.

TUBE PAINTS Tube colors are fairly easy to manage when mixing large amounts of paint. Clean the cap and tube thread before replacing the cap to prevent it from sticking. You can squeeze paint from a tube into a pan palette, and after it hardens, use it just as you would pan paints.

TWO-POINT PERSPECTIVE Giving an object two vanishing points, one left of the horizon line and one right of the horizon line.

UNITY Placement of design elements in relation to each other in a psychologically satisfying way or creation of an aesthetically pleasing whole.

VALUE The relative lightness or darkness of a hue, or of a neutral color varying from white to black.

WARM COLORS Colors with a yellow undertone.

WASH A thin translucent layer of diluted color laid over an area of paper too large to be covered by a single brushstroke. Washes can cover most of the paper of a small painting. For a large area, a lot of paint is needed and must be thoroughly mixed for laying the wash. Flat washes have a uniform color with no lines or ripples in paint. Gradated or graded washes are one color that's darker at the top. And variegated color washes have two or more colors. Some artists prefer a sponge to a brush for laying a flat wash over a large area. A wash can be applied to dry paper or damp paper. Dampening the paper helps colors blend but makes it less easy to control the paint because it will flow into any damp area.

WATERCOLOR Painting in pigments suspended in water and a binder, such as gum arabic. Traditionally used in a light-to-dark manner, using the white of the paper to determine values.

WET ON DRY A watercolor technique of painting wet color on a dry paper surface.

WET ON WET A watercolor technique of painting wet color on a wet paper surface. The paper can be saturated; use a small dish or washtub to wet the paper.

Metric Equivalents

0.63 cm = ¼ inch	20 cm = 8 inches
1.25 cm = ½ inch	25 cm = 10 inches
2.54 cm = 1 inch	30 cm = 12 inches = 1 foot
3.75 cm = 1½ inches	1 meter = 39 inches
5 cm = 2 inches	1 ounce = 28 grams
10 cm = 4 inches	1 pound = 448 grams

Standard 140-pound watercolor paper is usually 500 sheets (a ream), each measuring one square meter.

Acknowledgments

In my life as an artist, I've been blessed to have met so many terrific people, like Jim Penland. I couldn't possibly name everyone who has touched my life. Thank you all for being with me through the years while I was pursuing my dream.

To my best friend and spouse Fred, thank you for your unflagging confidence in me and for your loving support through our many years together. You've saved my soul.

To my children and their partners, Fred and Stephanie, Angela and Erik, and John and Laura, thank you for beautiful grandchildren who never cease to make me smile. They keep the child alive in me. Hayden, Haley, Tyler, Aiden, Ireland, and Cole, you are the loves of my life.

To all my students around the world, thank you for the great times. It has been wonderful watching you grow. What you don't know is that I owe you all so much for blessing me with your presence and fabulous insights.

Special thanks are due to Dick Rogers Photography for excellent photos of paintings for this book, and to Harold Thomas of J & R Photographers. I also want to thank Tim Hopper of Holbein Paints, Kevin Kelly of Canson Talens, Joe Miller of Cheap Joe's Art Stuff, and Lazar and Maryanne Tarzan of Lazar's Art Gallery for their valuable support.

A warm thank-you to Sterling Publishing's Charles Nurnberg, John Woodside, and Jeannine Ford for believing in me from the beginning and offering continued support for all my endeavors. To Margaret LaSalle, a beautiful human being and a special person, thank you for your trust and patience. To Rick Willett, my sincere appreciation for the outstanding print quality of my paintings.

To Jeanette Green, my editor and friend, who listened to me and cared in good and bad times, encouraged me to be the best I could be, and was always there with great ideas and loving support. Thank you for patience when I was intolerable, for your kind heart, and for always finding the best in people. And especially thank you for being the unique, lovely person you are.

Last and definitely not least, my great friend, Gary Brown, has been with me every step of the way, shaping me into the writer and person I am today. Gary, without your patience and understanding, I would not be where I am. How fortunate I am to have such a great friend and co-worker on this book. You are one very special person and I thank you with all my heart.

Index to Paintings

About the Author

Marcia Moses began her artistic career working with oils but soon fell in love with watercolor. Since 1989, she has taught watercolor workshops and led motivational seminars across the United States and Canada. Her watercolors have been exhibited in galleries and private collections all over the world. She has been recognized in *Who's Who in American Art* and is a member of the American Watercolor Society, Ohio Watercolor Society, and North Shore Arts Association of Gloucester, Massachusetts. Her first book, *Easy Watercolor* (Sterling), won a Gold Ink award and was named in the American Library Association's *Booklist* among the top ten hobby and craft books of 2003. Ms. Moses was educated in art at Kent State University and The Ohio State University. She lives in Canton, Ohio.

Index